DIY
Watercolor
Christmas

DIY
Watercolor
Christmas

Easy painting ideas and techniques
for cards, gifts and décor

INGRID SANCHEZ

DAVID & CHARLES

www.davidandcharles.com

Contents

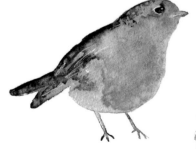
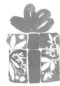

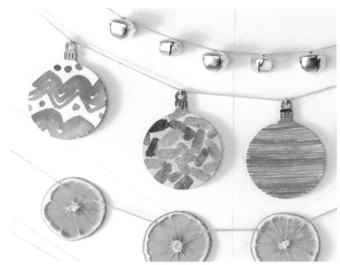
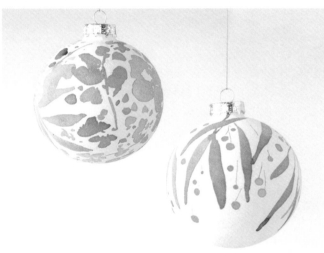
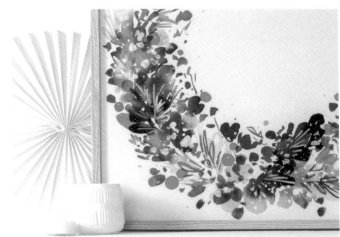

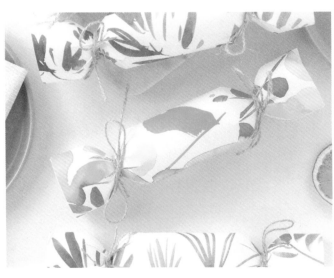

Introduction

Christmas is a wonderful time of year to use watercolors for décor, ornaments and gifts. We tend to think of watercolor for more summery themes and I'm perhaps best known for my floral paintings that epitomize the heady delights of the garden, but there is so much fun to be had with Christmas-themed designs in watercolor and that's what I'm excited to explore with you in this book.

Ever since I was a child I have loved painting in celebration of everyday joys and achievements, creating little notes to say thank you, congratulations or good luck. If you were sat at our table, it was not unusual to find one of my artistic gifts on your dinner plate, and my dad often found one of my painted surprises in his luggage when he was away on a work trip. As an adult I still enjoy creating cards and little paintings to surprise friends and family, and Christmas is the perfect time to make the most of that impulse to share and connect with others with our painting.

Even though I am a full-time artist, I still paint and draw in my free time. You can say that painting is both my job and my hobby, and I would love to share a little bit of this passion with you.

We'll explore the basics of watercolors with a glimpse beyond to some of my favorite techniques, all done with the final purpose in mind, to create cards, wall art and decorations for one of the most magical seasons of the year – Christmas!

I believe there is nothing more rewarding than creating something with our hands, but it becomes pure joy when we do it as a gift for others. I've also discovered that by painting festive decorations, such as tree ornaments, table decorations and hanging garlands, we can be sure that our homes reflect our own personal style.

The way you approach your watercolor painting will be as unique as you are, so I encourage you to explore the different options I have offered for you to try. There are simple exercises to play and practice with to find out what works best for you. Be patient and enjoy the process.

Happy Christmas painting!

Materials and Equipment

Due to its versatility, watercolor is by far my favorite art medium. With even the most basic beginner's set you can experience its magic, but start collecting watercolor in all its available presentations and it gets really interesting. In this chapter I outline the basics you will need for painting on paper, but before going supply shopping, take a look through Basics and Beyond: Experimental Watercolor for more options to enhance your work, and Project Preparation for materials required to prepare non-paper surfaces for painting.

WATERCOLOR PAINT

Watercolor paints are made from finely ground pigments held together with a water-soluble binder that fixes the pigment onto the paper. They come in solid, moist and liquid forms, and there are many quality brands to choose from; you can use them by themselves or mix and match between them. Let's start by looking at your options.

Solid form These include pans, sticks and pencils, with pans being the most traditional, named for the small plastic boxes that contain the solid watercolor paint. They can be bought individually or in sets with the pans fixed into a palette box. Pans need water to be activated and I recommend you use a spray bottle for this purpose. When the water evaporates the pigment remains and can be used many times, and they can last for many years because the pigments are hard to dissolve. Watercolor pans are a great option for small paintings or illustrations, and for artists who like to paint while travelling.

Moist form This watercolor paint comes in tubes and has a similar texture to toothpaste. If you use it directly from the tube you will get a very opaque effect, but mix it with water on your palette and you can create different levels of translucency. If you let it dry on your palette, it will harden and will need to be reactivated with water. Tube paint is a good option for artists who like painting big, and because it is easy to mix, it is also great for abstract paintings.

Liquid form Originally created for the graphics industry, watercolor ink is made with dyes instead of pigments, which makes it very concentrated. If you like vibrant colors this medium is for you, but keep in mind that artworks painted only with inks can fade with time, especially if exposed to light. For this reason, it is advisable to dilute the inks with water on your palette, or to mix them with your pans or tubes, which is a great way of creating new vibrant colors.

If you are a beginner, I suggest that you start with a set of pans that has enough colors to play with, to discover the possibilities of the medium. If you already have a pan set, why not add a set of tubes or inks to enrich the process? The brands that I recommend are: for pans and tubes, Winsor & Newton and Lukas; for inks, Dr. Ph. Martin's.

Whatever form you choose, all watercolor paint is water based. If it dries on your palette, just add a little bit of water and see how it comes back to life.

PAPER

Although it may sound obvious, it is important to make sure you buy paper that is made for watercolors. High-quality watercolor paper is made from 100% cotton, while more affordable papers will have a mix of cotton and wood pulp. Paper can be very expensive, so I recommend that you use student grade paper to play, practice and experiment; but for final project work it is better to invest in artist quality paper.

There are three main criteria to take into consideration when buying paper:

Weight Paper is measured in pounds (lbs) or grams per square meter (gsm) and this affects the thickness of the paper. Paper weight can go from 90lbs (185gsm) up to 300lbs (600gsm). The lower the number the thinner the paper, and the greater the likelihood that it will buckle. For the projects in this book, 140lbs (300gsm) is more than thick enough.

Texture The name of the paper will refer to it as being 'hot pressed', 'cold pressed' or 'rough'. Hot pressed is the smoothest of all the watercolor papers, cold pressed has some texture and rough has a lot of texture. My preference is to use paper that has some texture to it, but this is very much a matter of personal choice.

Format Paper can be bought in sheets, spiral pads, blocks and rolls, and your choice may be determined by your painting style and how much you paint. I paint a lot, so I buy rolls, cutting off the paper to length as I need it, but a pad or block may suit an occasional painter better. Blocks where sheets are glued on all four sides are a great option to start with, because the paper is already stretched and so it will not buckle.

MY PAPER RECOMMENDATIONS

For the projects in this book I would recommend the following block brands. That way you can get started right away without worrying about stretching your paper.

For cards Block of Fabriano Artistico 140lbs (300gsm), 5 x 7in (13 x 18cm), cold or hot pressed, depending on your preference.

For pictures Block of Winsor & Newton (or Arches) 140lbs (300gsm), 12 x 16in (30 x 40.5cm), cold or hot pressed, depending on your preference.

With paper blocks, the sheets are glued to prevent the paper from warping. Once you finish your painting, let it dry completely then remove the sheet from the block by tearing it away from the glue-free corner.

BRUSHES

There is a huge selection of brushes available, and you can choose from ones made from synthetic, mixed fiber or natural hair. Many artists prefer natural brushes because they can hold lots of water, but personally I prefer to use synthetic brushes as they are easier to take care of and can last for years.

You will need a variety of brush shapes to achieve specific shapes – circles, lines, leaves, etc. – and these are the ones that I have used in the painting of the projects in this book:

For fine lines and details Winsor & Newton, Cotman Series 222 Designers Brush #0.

For small leaves and filling areas Winsor & Newton, Cotman Series 222 Designers Brush #6.

For larger botanicals, circular shapes and filling larger areas Daler Rowney, Aquafine Brush, Round #12.

For flat washes, splattering and experimentation
I recommend you buy a set of student grade brushes. These are usually more affordable and come in packs of several brushes, ideal for a variety of uses. Try Foundation Brushes (available in packs or three or six brushes) or the Cotman range, both from Winsor & Newton.

ADDITIONAL MATERIALS

Apart from paint, paper and brushes, there are some basic supplies we will need to start painting, as listed here:

Palettes For mixing watercolor tube paints and inks. Porcelain ones are the best: the paint stays moist longer, the pigments are easier to mix and they don't stain, making them very easy to clean. If you don't have a porcelain palette, a porcelain plate works just as well.

Painter's tape (for better results use blue tape, also known as blue painter's masking tape). If you choose watercolor sheets instead of blocks, use this to stick your paper to your table or a wooden board before beginning to paint; it is also helpful to mask some areas of the paper when painting as we will explore in Experimental Watercolor.

Pencil and eraser You may choose to sketch and draw an outline as a guide to painting or to define a silhouette, so keep a pencil handy. Use the eraser to erase any visible lines at the end. You will also find it helpful for removing masking fluid (see Experimental Watercolor).

Two or three jars of water Line these up to wash your brushes and avoid contaminating your palette when using different colors.

Cloth or paper towels Essential to maintain a clean workspace, these are also helpful to absorb and control the amount of water from your brushes as you paint, to create texture on the paper, and to remove masking fluid when applied in large areas.

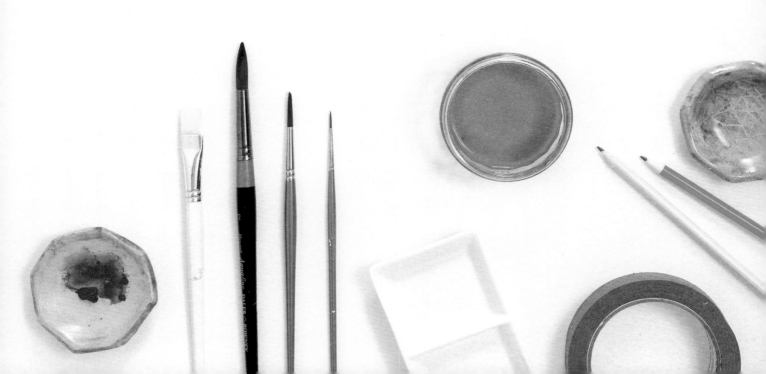

Understanding Color

Once we understand color, we can paint with intention. Use it wisely and it will become your best ally in painting beautiful pieces. I want to introduce you to the basics of color theory and how to apply it to watercolors, so that you can create your own unique Christmas palette beyond red and green.

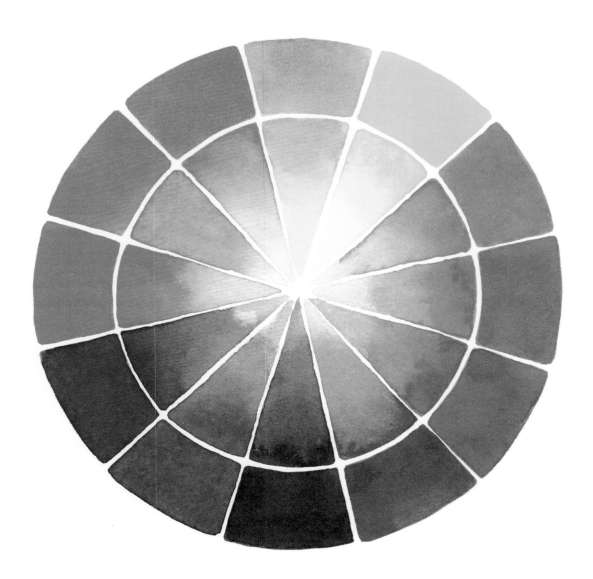

THE COLOR WHEEL

The color wheel is based on the three primary colors: red, yellow and blue. These three pigments cannot be mixed from any other colors, but you will be surprised to discover the endless possibilities they provide to create lots of new colors once we start mixing them together. Just take a look at the color wheel I painted here using only the three primary colors.

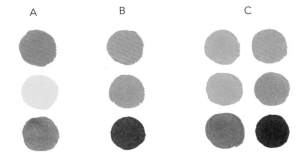

A Primary colors: red, yellow and blue.
B Secondary colors (a mix of two primary colors): orange, green and violet.
C Tertiary colors (a mix of one primary and one secondary color): yellow-orange, red-orange, yellow-green, blue-green, blue-purple and red-purple.

UNDERSTANDING WATERCOLORS

The primary quality to remember when working with this medium is that watercolors are translucid: just add more water or pigment to make them as transparent or as opaque as you wish.

In this example, my primary red color is at its highest concentration on the left. The more water I add to the mixture the more translucid it becomes, until it is almost transparent in the last circle. This is also called 'color value', i.e. the lightness or darkness of the color.

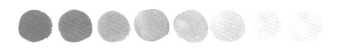

More varieties for our palette are possible if we experiment with black. When we add black to any color, we change its shade. In this example, note how red, yellow and blue have a completely different voice when mixed with black.

COMMUNICATING AN EMOTION USING COLOR

One of the easiest ways to create a palette is to think about the emotion you want to convey and to translate that to color temperature, using cool or warm colors.

Cool colors – greens, blues and violets: these transmit a sense of calm, but can also express sadness. In a Christmas context, they make me think about a still winter's night or a snowy landscape.

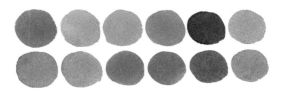

Warm colors – reds, oranges and yellows: these are more energetic and evoke a feeling of happiness. In a Christmas context, they make me think about gifts, cookies and a hearth-side scene with all the family gathered around a roaring fire.

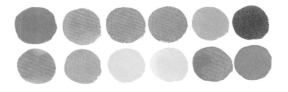

Did you know that to achieve white in your watercolor you use the white of the paper itself?

CREATING A CHRISTMAS PALETTE

Now you have lots of tools to start creating your own Christmas palette. Remember: you can play with the translucency of a color by adding water to it, you can change its shade by adding black to it, and you can create a scheme based on the temperature of the colors you choose.

MAKING A START

Before you start mixing colors, do make a basic plan for your painting first. In this way, you will be able to fully focus on the painting process instead of worrying about what color to use next.

Here's a simple way to start planning a painting scheme:

1 Choose your theme, e.g. 'snowflakes'.

2 Consider, what are the qualities of your theme? Snow is cold, so use cool colors like blue.

3 Make variations on your chosen colors by adding black or gray, or another cool color, such as green.

Snowflakes: cool colors.

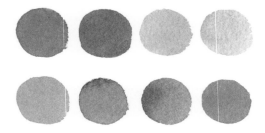

MORE COLOR SCHEMES
Berries on a branch: warm colors.

Traditional Christmas tree: cool and warm colors.

Modern Christmas tree: cool colors.

Gingerbread man: warm colors.

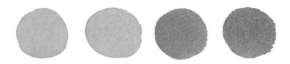

SKETCHING TO TEST YOUR PALETTE

Once you have created your palette, it is advisable to test your colors by painting some of the elements that you are planning to add into your composition, such as leaves or berries for example. Sketching like this will put your colors into action and you will be able to see if you are happy with them or if you need to make any changes. It is an opportunity to explore key colors and to test unusual colors too.

EXPLORE KEY COLORS

During the 'sketching to test' process, we can influence the sentiment of our painting by adding a dominant color, referred to as the 'key color'. Using a key color can be helpful to place our scene in a specific place or time. In my example, compare the branch where black has been added with the one where the key color is yellow; see how it looks very neutral in comparison to the other, which is so vibrant. Then, where the key color is blue, it is almost as if the branch has been placed beneath the moon, reflecting its light.

TEST UNUSUAL COLORS

There is a simple trick we can use to bring a modern sensibility to a traditional theme such as Christmas, and that is to invite an unusual color to our palette. In my example, I have started by sketching some berries using a standard palette of red and green – a natural combination that is pleasing to the eye. Then, I have explored other less obvious color partnerships: you can try any variation you can think of to see how it feels – use yellow or turquoise instead of green, orange or purple instead of red.

Branches: cool colors.

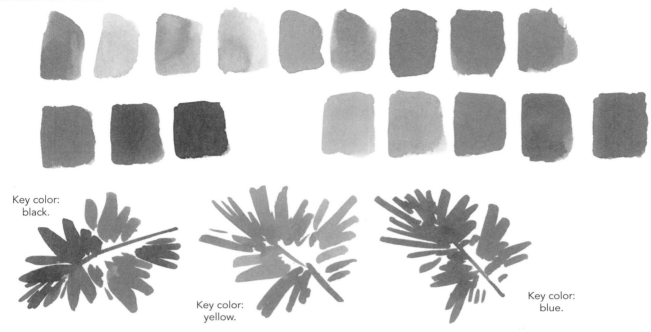

Key color:
black.

Key color:
yellow.

Key color:
blue.

Berries: warm and cool colors.

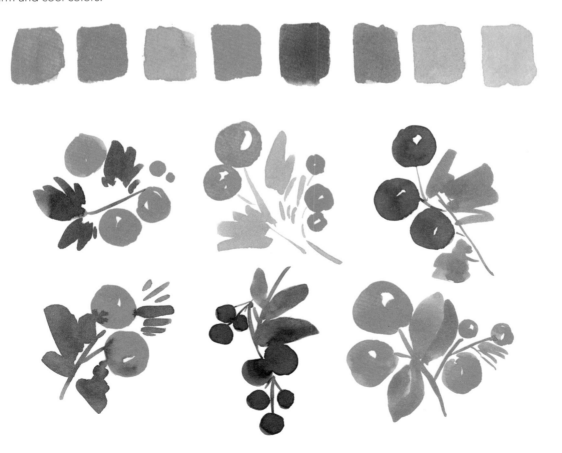

MY PALETTE

This is the list of all the watercolors that I have used for the projects in this book. My paintings usually look very colorful because I rarely use a color by itself; I prefer to mix colors to create unique shades. This approach makes my palette messy but more interesting.

I have used my full watercolor palette to create a 'confetti' pattern to explore the variety that can be achieved. You can try this for yourself with the colors you have at hand. Discover how many combinations you can create with just a few colors; remember to play with the translucency by adding more water to your brush.

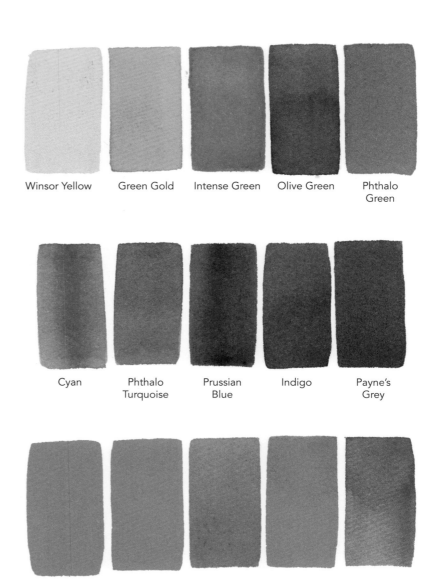

Winsor Yellow	Green Gold	Intense Green	Olive Green	Phthalo Green

Cyan	Phthalo Turquoise	Prussian Blue	Indigo	Payne's Grey

Cadmium Red	Cinnabar Red	Burnt Sienna	Carmine Red	Indian Red

All the paintings in this book use colors mixed from my palette.

If you have some watercolor inks, try adding one drop to your palette to see how the colors become more vibrant.

UNDERSTANDING COLOR

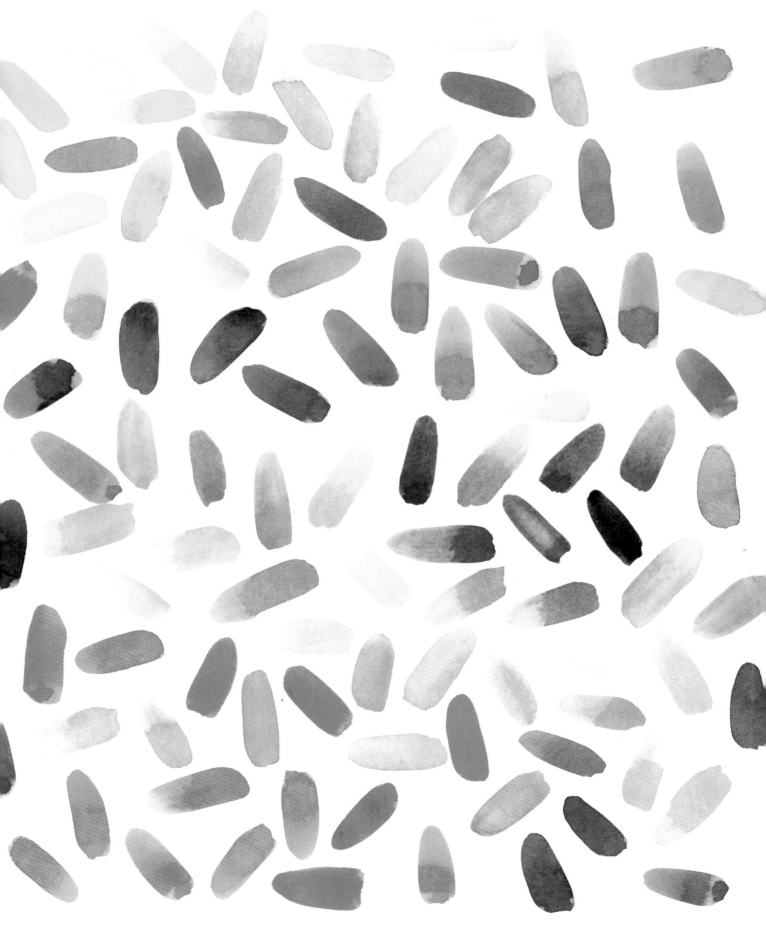

Basics and Beyond

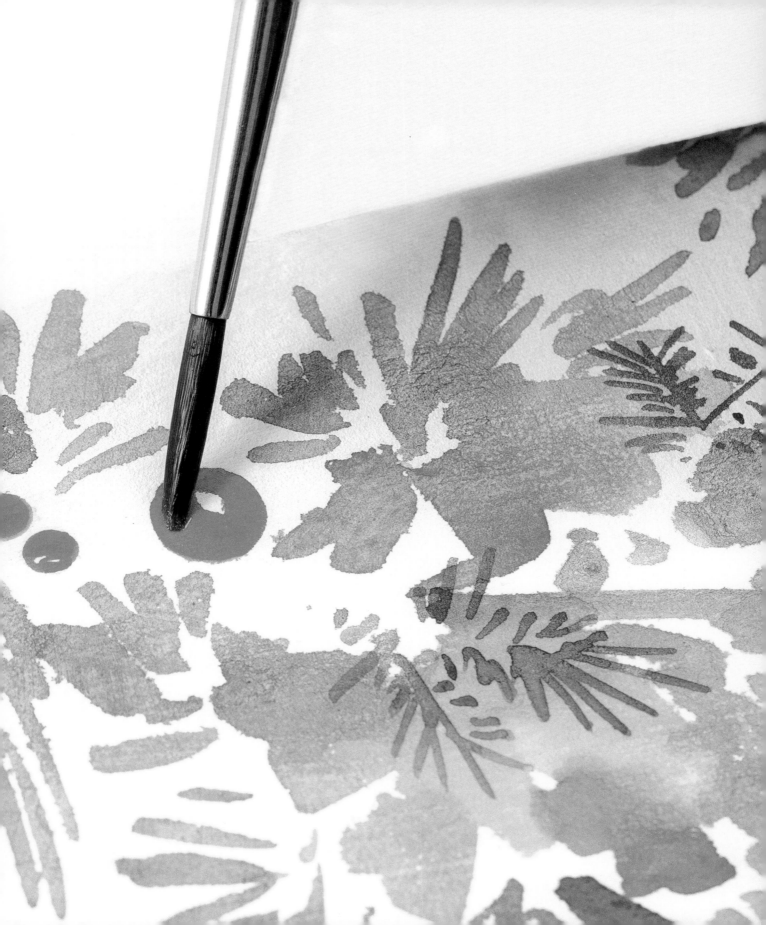

Washes and Textures

There is no doubt that watercolor is a challenging medium but fortunately, through practice and exploration, we can master it. In this chapter and the one that follows (Lines and Shapes), we are going to learn different techniques that will help us to approach this medium with more confidence. I invite you to take as much time as you need. It is also a good idea to use student grade paper until you feel more confident. Happy painting!

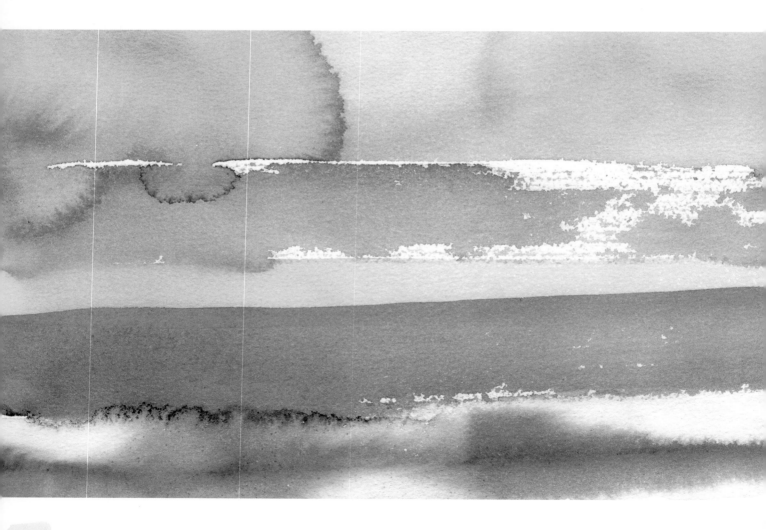

WATERCOLOR WASHES

In order for watercolors to work, we need to understand the balance between water and pigments, and I have found that one of the best ways to grasp this is to paint all kinds of watercolor wash. A wash refers to a large area covered with diluted paint to make it semi-transparent, which is relatively easy to achieve as watercolor is naturally translucid. We can use washes to create a background or as the base for an effect as we explore here.

WET ON WET

When we are painting wet on wet, this simply means that we are painting onto wet paper.

1 Wet your paper using your brush or a sponge. Dip your brush into your paint and apply it to your paper. See how the pigments dissolve into the water creating a beautiful smooth finish.

Wet on wet flat wash.

WET ON WET FLAT WASH

If you add color to the whole area you will achieve a flat wash.

1 Wet your paper using your brush or a sponge. Move the pigments from side to side and keep adding more paint to your brush to get an even color.

The paper has the right level of moisture for a wet on wet technique if, when viewed from the side against the light, it shows a shiny surface.

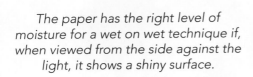

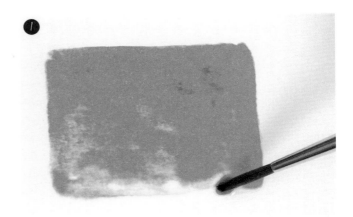

WET ON WET GRADIENT WASH

In a gradient wash the color becomes increasingly diluted until it fades to its lightest value.

1 Wet your paper using your brush or a sponge and simply move the pigments horizontally without adding more paint to your brush.

2 If you have a lot of paint in your brush, you might need to dip it into clean water and remove the excess with a paper towel. Since the paper is wet, there is no need to add more water to it. Remember that we are just moving the pigments that are already on the paper.

Wet on wet gradient wash.

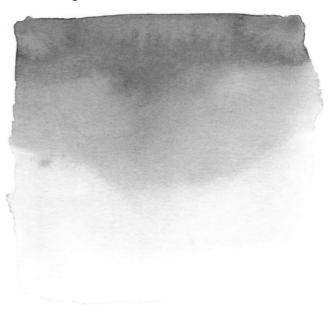

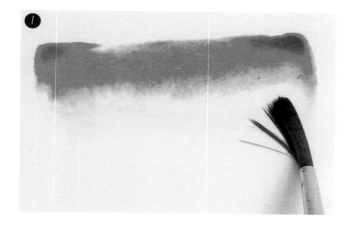

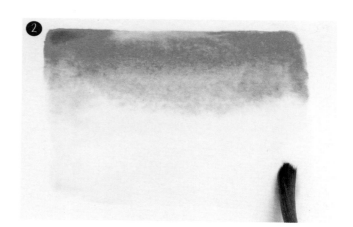

Beads of water on the edges of the paper show an excess of moisture, which will create a different effect. To maintain an even color, use the tip of a clean, dry brush to absorb it.

WASHES AND TEXTURES

WET ON SUPER WET

I devised the wet on super wet concept to explain to my students how I achieve some of the effects in my signature floral paintings. Here the paper has much more water on it than with the traditional wet on wet technique.

1 Wet your paper using a lot of water until you can see a little pool sitting on top of the surface. Dip your brush into your paint and use just the tip of the brush to touch the paper to see how the pigments expand.

2 The effect created will vary according to the amount of pigment used.

Wet on super wet.

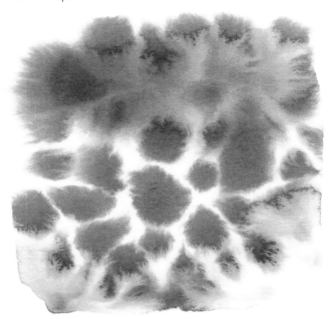

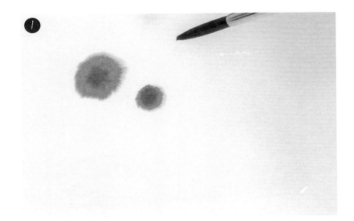

The amount of water used matters as can be seen by comparing the wet on super wet technique with the wet on damp technique (see Wet on Damp).

WET ON DAMP

Wet your paper the same way as for the wet on super wet technique, but allow the water to sit for a while to be absorbed into the paper.

1 Use the tip of the brush to start adding dots of paint when the surface of the paper is just damp.

2 The effect is so much smoother than with the wet on super wet technique, and where the paper has fully dried, no effect will be achieved in those areas.

Wet on damp.

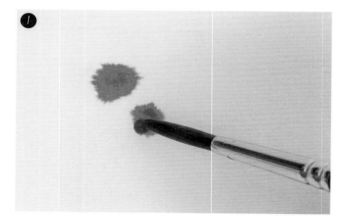

It is normal that some areas will dry fully while others remain wet. Use this exercise to learn through observation how the moisture levels affect the flow of the pigments.

WASHES AND TEXTURES

DRY ON DRY

When we are painting dry on dry, this simply means that we are painting onto dry paper.

1 It is possible to paint a wash with just the minimum of water necessary to activate the paint, but note that how much pigment we use will affect the marks we leave on the paper.

2 If we use a minimum amount of watercolor, eventually the brush will run out of paint.

3 Play with your brush and try making random shapes using this technique.

SUPER DRY ON DRY

The drier our brush is, the more texture we will create, as we will see with what I call the super dry on dry technique.

1 Without water the brush will quickly run out of paint and the marks will be more noticeable.

2 I like using this technique on paper with lots of texture to get very interesting effects.

3 Try painting some fast brush strokes to explore new ideas for future projects.

BLENDING VS LAYERING

When we blend, two colors are merged together so that we don't know where one ends and the other begins. By simply allowing two brush strokes with different colors to touch slightly, blending happens naturally. When we layer, we take advantage of one of the main qualities of watercolors, its transparency, but to achieve this effect we need to allow the first layer to dry before applying the next; if it is not dry, then we will get some blending.

Blending: working fast is key, both colors need to be wet enough for a smooth blending to happen.

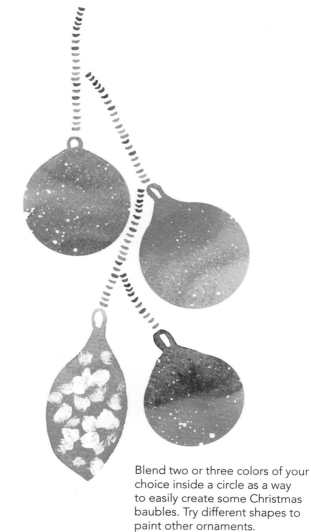

Blend two or three colors of your choice inside a circle as a way to easily create some Christmas baubles. Try different shapes to paint other ornaments.

Layering: remember that the more water you add, the more translucid your watercolor paints will become.

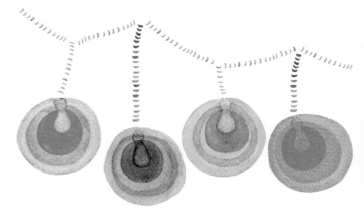

When we layer using only one color we can see its value in action. Use this technique to create the effect of light on a string of fairy lights, or for candles, or for celestial objects.

WASHES AND TEXTURES

BLENDING IDEAS

Here are a few ways in which you can begin to use blending in your pictures.

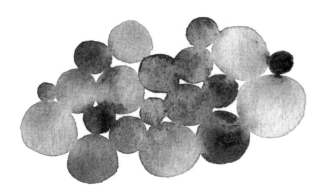

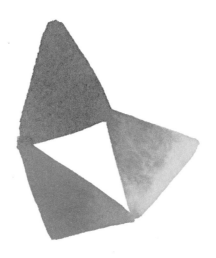

USING ONE COLOR IN DIFFERENT VALUES

Allow circles with different sizes and values to touch each other while still wet and see how they blend. By using only one color, as seen here, we will practice working with the value of a color. Refer to the Blending Circles exercise in the Lines and Shapes chapter for detailed steps.

PAINTING TRIANGLES WHERE THE TIPS TOUCH

Paint a group of triangles using different colors and allow their tips to touch each other; note how we can create new colors during the process. This technique will be used in DIY Projects: Keepsake Boxes.

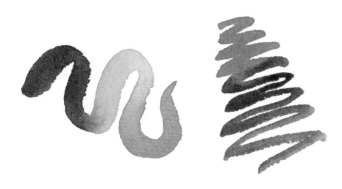

CHANGING THE COLOR IN YOUR BRUSH IN THE MIDDLE OF A LINE

Start painting a line with one color, dip your brush in a different color and continue your line while it is still wet. You can change the color in your brush as many times as you want. For more ideas see Lines and Shapes: Using Lines to Paint Botanicals.

Let your imagination fly while playing with the position of the triangles. I painted an orange by pointing all my triangles to the center of a circle.

CREATING SIMPLE SHAPES

Creating washes is a lot of fun, but eventually we will want to use what we have learnt about the balance of water and pigment and the blending of colors to create some shapes, for example, if we want to paint a card filled with Christmas trees. Taking this as my inspiration, I have painted three Christmas trees, all in the same style and shape, but each realized using a different technique for the application of the paint.

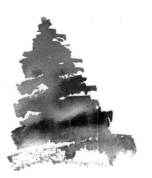

Wet on wet
Christmas tree.

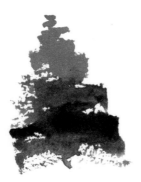

Dry on dry
Christmas tree.

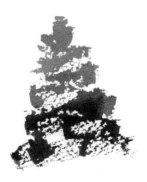

Super dry on dry
Christmas tree.

WET ON WET CHRISTMAS TREE

1 Wet your paper by painting the shape of your tree using a wet brush. (This can be done with clean water, but if you add a bit of light green color it is easier to see what is happening.)

2 Start applying watercolor from the top of your tree, moving the pigment very slightly.

3 Change the color when you want to: since the shape is wet, there is no need to move the pigments too much and you should just allow the water to blend them naturally.

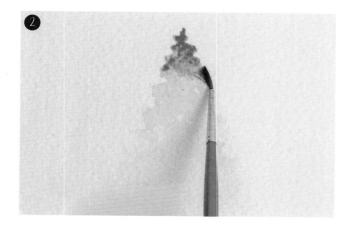

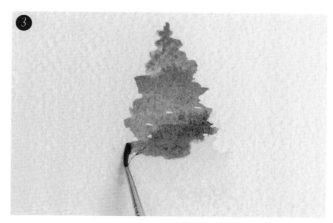

DRY ON DRY CHRISTMAS TREE

1 Dip your brush in your watercolor and start painting your tree directly onto the (dry) paper, working from the top down.

2 Change the color midway, making sure the colors touch each other. Even though the paper is dry some blending can still happen if there is enough water.

SUPER DRY ON DRY CHRISTMAS TREE

1 With much less watercolor on your brush, begin to paint the shape of the tree from the top down and change the color halfway down.

2 When the brush is so much drier, notice how much more texture is achieved.

The texture achieved with the super dry on dry technique is especially good when cold pressed paper is used.

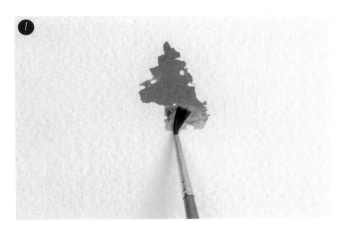

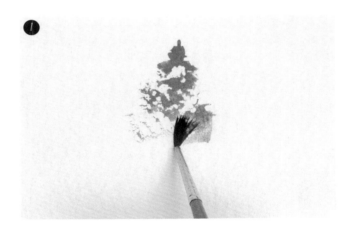

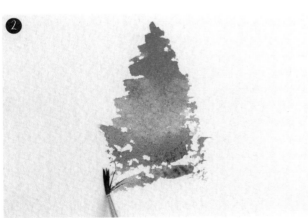

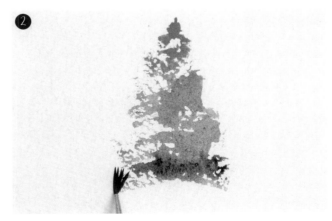

Lines and Shapes

Now that we know all about washes and textures, it is time to explore painting shapes and lines, and key to this is choosing and using your brushes. Take your brushes out, analyze their forms and start exploring their unique qualities, as every brush will offer you different results. I am going to introduce you to some simple activities to help you to understand the importance of your brushes in developing your style. Remember that there are many ways to achieve beautiful paintings, let's discover yours!

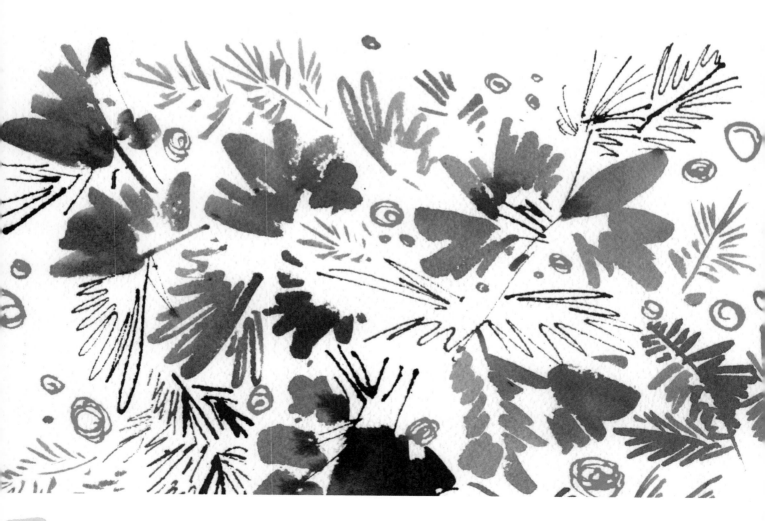

PAINTING LINES

The first thing to do is to discover the potential of your brushes. You will notice that brush bristles come in different shapes and sizes: some are round, some are pointy, some are square. These differences mean that their brushstrokes will naturally give you varying shapes.

Try experimenting with each type of brush by painting lines and applying varying degrees of pressure as you go. Make sure to take advantage of the whole of the bristle. Change the amount of pressure that you apply while moving the brush. This will help you to understand how much water your brush can hold and how thick or thin your lines can be.

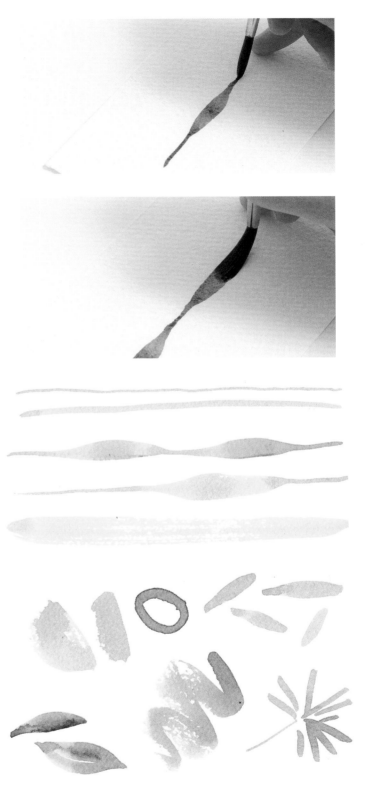

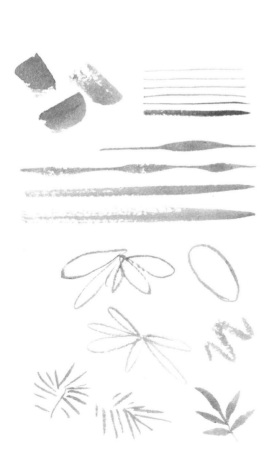

Lines and shapes made using Winsor & Newton, Cotman Series 222 Designers Brush #0.

Lines and shapes made using Winsor & Newton, Cotman Series 222 Designers Brush #6.

USING LINES TO PAINT BOTANICALS

Now try painting some botanical motifs using just lines. Change the color in your brush to create blending and remember to play with the pressure you add to your brush.

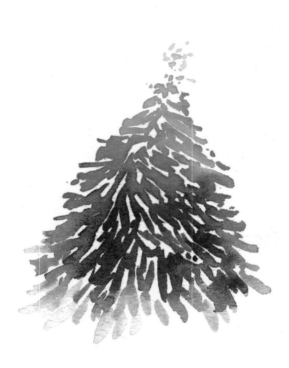

Botanicals made using Winsor & Newton, Cotman Series 222 Designers Brush #6. With a small brush we can create thick lines by applying a lot of pressure or very fine lines by using just the tip. Many lines together can help us to create a more complex idea, like a pine tree or a group of branches.

It may sound very obvious, but keep in mind that the bigger your brush, the bigger the brush strokes will be. Your painting will be more dynamic and interesting when you use different brush sizes and shapes.

LINES AND SHAPES

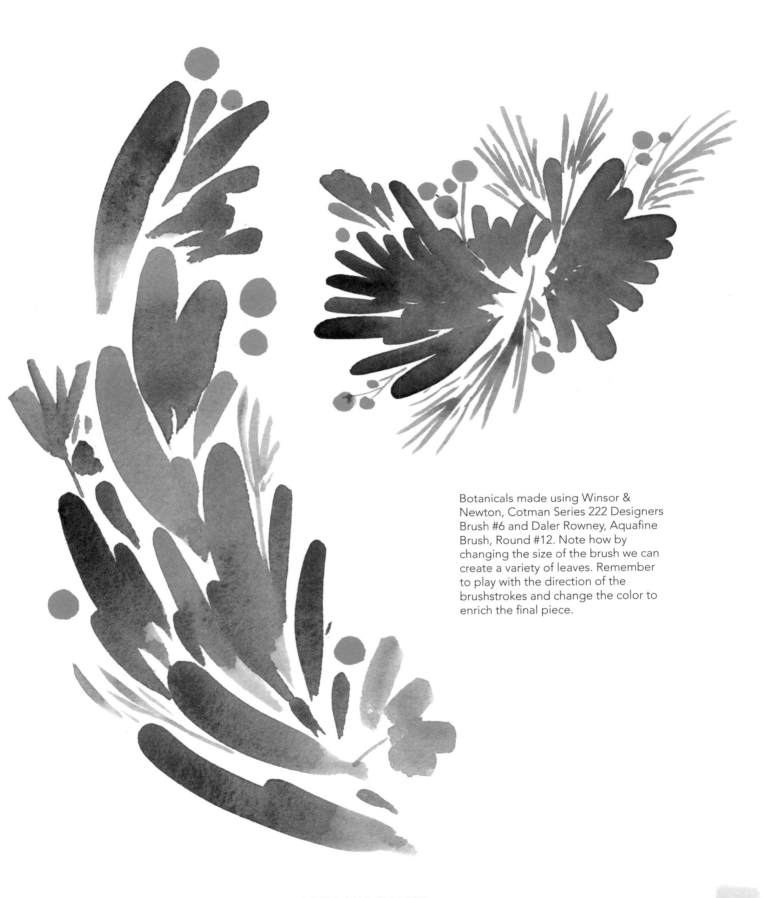

Botanicals made using Winsor &
Newton, Cotman Series 222 Designers
Brush #6 and Daler Rowney, Aquafine
Brush, Round #12. Note how by
changing the size of the brush we can
create a variety of leaves. Remember
to play with the direction of the
brushstrokes and change the color to
enrich the final piece.

PAINTING SQUARES AND CIRCLES

When I have students in the studio, one of the first things I ask them to do is to fill a page with squares. Although the purpose of the exercise is to play with the values of the colors used, I love observing how they go about it, as how they construct a square tells me a great deal about their art practice preferences.

If painting a square, I'd start by choosing the right brush for the task, one whose form will make it easier to paint it directly onto the paper, so ideally a flat brush. But many people prefer to draw the square first then fill it with watercolor – I call this 'draw and fill'.

Whether you choose to paint or to draw and fill, both will produce a square that looks pretty similar, but as we look to produce more complex shapes, the final result will be completely different depending on the approach you choose to take, and it is choices such as these that will help you to establish your own painting style.

There is no right or wrong here, of course. I never draw first because I prefer working with the natural flow of the medium; as a result, I have a very loose and dynamic style. If you are new to the watercolor medium try both approaches and see what works better for you. Start with basic shapes like squares and circles.

PAINT

For the square, use the shape of a flat brush to paint the watercolor directly onto the paper.

For the circle, use the shape of an oval brush to paint the watercolor directly onto the paper.

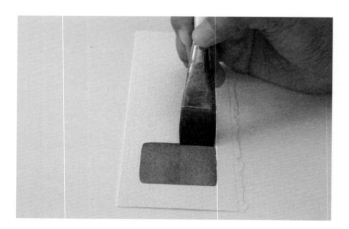

DRAW AND FILL

This applies for any shape. Draw the outline of the shape first with a pencil, then fill the shape with watercolor using your favorite brush.

The finished squares: paint (left) and draw and fill (right).

The finished circles: paint (left) and draw and fill (right).

If you choose to draw the shape first, use an HB (hard black) pencil with a very light touch, to avoid scratching the surface of the paper; alternatively, use a watercolor pencil.

EXERCISE:
BLENDING CIRCLES

The intention of this exercise is to help you to understand what is the right balance between water and pigments in the creation of values and blending. Working fast is key here because the circles need to be wet enough to allow them to blend into each other.

1 Prepare your colors. Here I have chosen a cool color – blue.

2 Start by painting a circle with enough water on it that it will allow you time to paint a second one before it dries. As you paint the second circle, let it slightly touch the first circle. You will see some blending start to happen; let the water and pigments flow naturally and avoid touching them again.

3 Continue adding more circles around the paper, always allowing them to touch each other, and as you do so explore the concept of value as described in step 4.

4 By adding more water to your paint, the circles will be more transparent; by adding more pigment, the opacity of the circles will be increased. Circles with different values alongside each other will be more interesting than using just one color value.

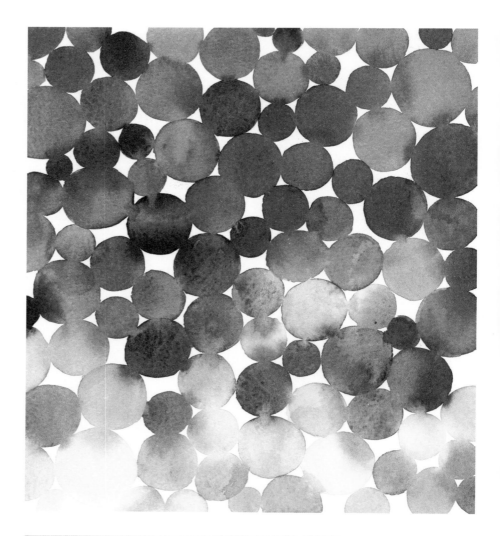

Work fast, or use a lot of water, to avoid the circles drying out before they can blend.

EXERCISE: LAYERING CIRCLES

This wet on dry exercise is a fun, easy way to practice layering while taking advantage of the transparent quality of watercolor. Unlike the Blending Circles exercise, here we need to be patient and wait for each layer to dry completely.

1 Prepare your colors. Here I have chosen a warm color scheme, using a palette of red, orange and yellow.

2 Paint several circles around your paper (see step 3) so that they **do not** touch each other.

3 Change their color values by varying the amount of water and pigment used. The more translucid a circle is the more layering it will allow.

4 Let your first layer of circles dry fully, then you can add more circles repeating steps 2 and 3.

5 You can continue to add as many circle layers as you wish, always remembering that each new layer should be allowed to dry before painting another.

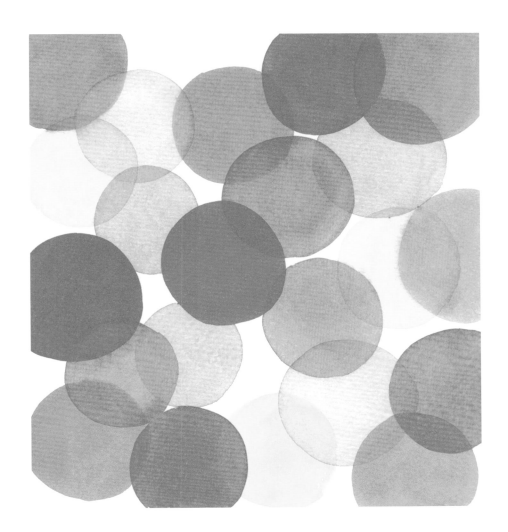

You can use a hair dryer to speed up the drying process, but not too close to the paper! Allow the paper to cool off before adding a new layer of circles.

PAINTING LEAVES

Let's explore applying both the paint and the draw and fill approach to painting to a more complex shape, such as leaves. It is possible to paint leaves using any brush, but the brush you choose will produce very different results. We are going to paint a very simple leaf, concentrating purely on the silhouette, and for this exercise we are using a round brush. Prepare your colors first – greens and blues work very well together.

PAINT

1 Start with the point of your brush to get a fine line at the tip of one leaf, adding more pressure as you move your brush.

2 To finish the leaf, return to the point of your brush to get a fine line. Continue adding as many leaves as you wish. To get a natural blending, add different colors to your brush during the entire process.

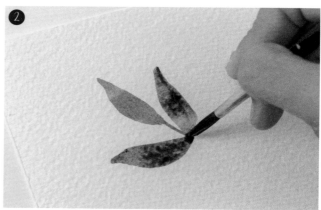

DRAW AND FILL

1 Use a pencil to draw the shape of your leaves, completing the whole sprig.

2 Start filling the shape you have drawn with watercolor; remember to vary your colors while you move the pigments around. Once it is completely dry, erase any visible pencil lines.

To warm up for this exercise, revisit experimenting with your brushes in Painting Lines.

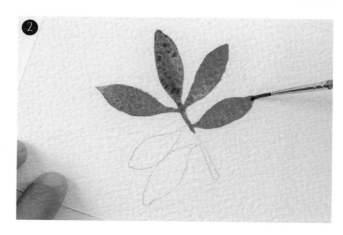

The finished leaves. Can you see the difference? The ones painted on the go (left) have looser shapes, while the draw and fill ones (right) look very neat with very clean lines.

PAINT OR DRAW AND FILL: WHICH STYLE WORKS BETTER FOR YOU?

If you tried both approaches, you probably noticed that not only is the result different, but also the process. Painting directly onto the paper is usually faster and it requires a certain mental agility, as you need to decide quickly where to go next before the water dries. Drawing and filling, however, allows you to work more slowly and can be very meditative.

There can be dramatic differences in the results. Compare the crisp lines of the draw and fill stars (left) with the loose blending on the stars on the right, where I painted directly onto the paper. Even though I used the same colors, the loose brushstrokes grab more pigment concentration making the colors more vibrant.

I have had students that find my loose style incredibly liberating, while for others it can be very stressful not knowing what is going to happen next. Although I love the neat result of draw and fill, I prefer to paint intuitively. Watercolor should be fun and joyful, so try both ways and discover what works better for you.

Experimental Watercolor

Watercolor is a really versatile medium and it becomes incredible once we combine it with other media, for example, acrylics or gel pens, or with alternative materials readily available in our homes, from salt and alcohol to children's art supplies. You'll also discover here how what you use to apply your watercolor with can make a dramatic difference.

SALT TEXTURING TECHNIQUE

Applying common table salt to our watercolors can create beautiful results. When the salt dissolves it pushes away the pigment to create a starry effect. The outcome can vary enormously depending on the amount of color pigment used, the amount of water that is on the paper, and the size of the grains of your salt.

If the paper is very wet, sometimes the salt just dissolves without showing any effect at all. On the other hand, if the paper is barely damp, the granulation can be very dense. Table salt leaves behind small dots and can easily disappear in the water, while kosher (coarse-grain) salt will hardly dissolve at all, leaving the individual shapes of the grains on the paper. For an extreme effect, I recommend that you work with a lot of pigment. Each time the result will be completely different making every piece unique.

1 Paint a wash in one or more colors and let it sit for a couple of minutes.

2 Sprinkle some salt over it and leave it to dry. The effect is not immediate, it takes some minutes to start showing. Don't be tempted to move it; just be patient. If you're using kosher (coarse-grain) salt, add more pigment on top of the grains with the tip of your brush.

When the paper is completely dry, simply brush the salt off with your hand.

Salt texturing technique using table salt.

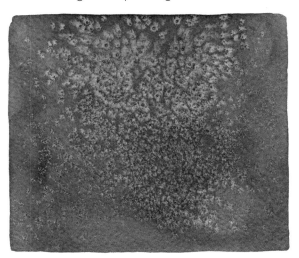

Salt texturing technique using a mix of table salt and kosher (coarse-grain) salt.

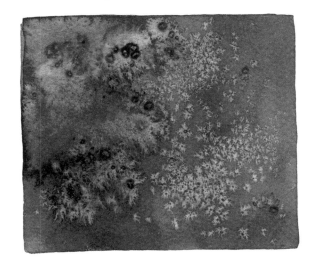

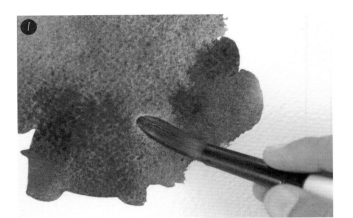

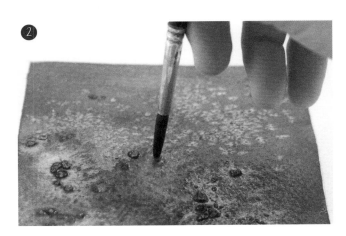

WET ON WET PLUS

Another way to create an unusual watercolor effect is by adding other liquids to our washes, from rubbing alcohol (surgical spirit) and vodka or gin, to bleach and soapy water. I particularly like to use alcohol and soap because they are safe to work with, and I enjoy the meditative element they bring to the process.

ALCOHOL

Alcohol pushes the pigment away in a similar way to salt, but because it evaporates, the effect is almost ghost-like. It can be applied with your brush, a cotton swab, a sponge, or even a spray bottle. I like to use a cotton swab as it gives me the control I am looking for. I love doing this: I find the process very relaxing, and it is one of the few techniques where I try to manipulate the final effect.

1 Paint a wash – it needs to be wet for the alcohol to work. Apply dots of alcohol using your cotton swab.

2 Feel free to push your cotton swab into the paper to see what happens. Enjoy the magic of it: if you see that it disappears completely, simply go back and add more dots of alcohol. You can do this again and again.

Wet on wet plus alcohol.

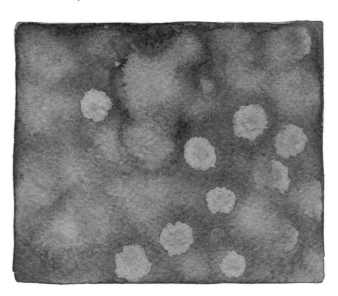

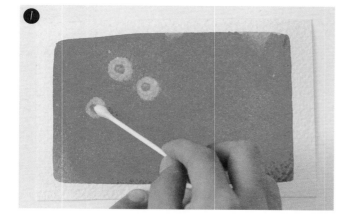

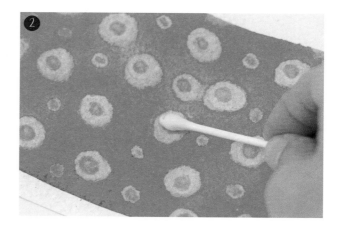

SOAPY WATER

By adding a soapy water mix onto your watercolor wash, the effect will be very similar to the starry effect we get with the salt texturing technique, but it will be smoother leaving none of the marks made by the grains of salt. To create the soapy water mix, add a few drops of dishwasher soap (washing-up liquid) into half a glass of water.

1 Paint a wash – it can be wet or damp when we start adding the soapy water mix. Apply drops of your soapy water mix using a brush, but don't move the mix around the paper – just leave it to expand and dry naturally.

2 Alternatively, splatter the soapy water onto the paper for a more dynamic effect.

Wet on wet plus soapy water.

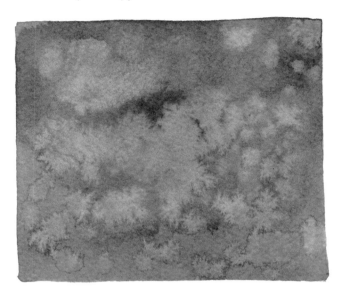

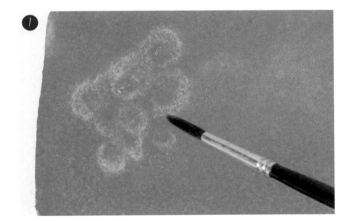

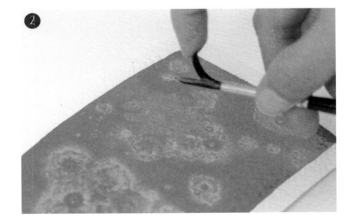

RESIST TECHNIQUES

We can use a variety of materials to help us to create a seal to preserve some of the white of the paper as we paint – painter's tape, crayons, wax, glue, stickers, and my personal favorite, masking fluid. All of these work by repelling or blocking the water.

MASKING FLUID

This is a very versatile material to use for the resist technique, preserving the white of the paper while achieving clean crisp lines and edges. Layering is also possible to create spectacular and unusual effects. However, it can be challenging for beginners, and there are a few important things you must remember:

- Always prepare your brush before using it to apply masking fluid (see Preparing Your Brush).

- Only apply and remove masking fluid from paper that is completely dry.

- Let the masking fluid dry completely before applying a layer of wash, and be sure to allow the first layer of wash to dry completely before applying another wash layer.

Resist technique using masking fluid.

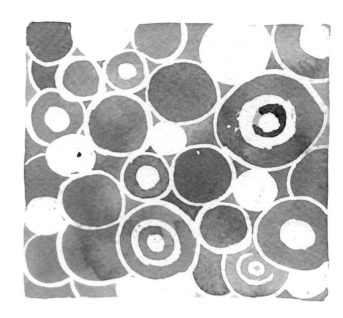

PREPARING YOUR BRUSH

Brushes can be easily ruined if the masking fluid dries on them, so before using your brushes to apply the masking fluid, it is necessary to soak them in a glass of water that has had a teaspoon of liquid soap mixed into it. Remember to do this each and every time you apply more masking fluid – it really will save your brushes.

Masking fluid is used to create the bright white areas on this gift.

EXPERIMENTAL WATERCOLOR

1 Use a pencil to draw circles in different sizes, letting them touch each other. Dip your prepared brush (see Preparing Your Brush) into the masking fluid and use it to start 'drawing' on top of your pencil drawing. You can vary the thickness of the lines and fill some of the circles completely. Remember to continue to dip your brush into the soapy water each time you add more masking fluid – this will make it thinner and easier to apply. Once you have finished applying the masking fluid, allow it to dry completely.

2 Check that the masking fluid has dried completely before painting your first layer of wash across the surface of the paper.

3 Paint a wash using one or more colors. Once it is dry, feel free to paint a second wash if needed.

4 Once the wash is completely dry, start rubbing the masking fluid with your fingers to remove it.

Wash brushes under running water, using soap, to clean away all the masking fluid.

You may find that an eraser helps you to remove the masking fluid more easily.

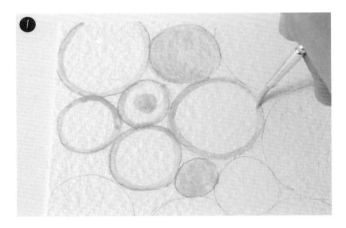

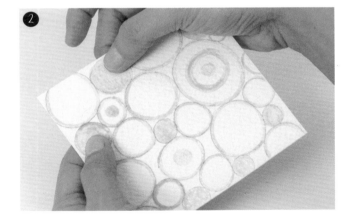

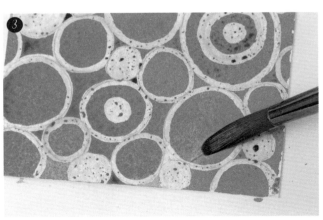

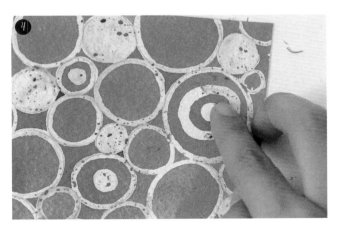

WHITE WAX CRAYON

This is an easy material to use for the resist technique, making it ideal if you are looking for an activity to do with children. The results are more rough and ready than when using masking fluid and crisp lines are difficult to achieve, but the imperfection of them can be a nice touch. The more texture your paper has, the more challenging it will be to get clean edges, so if you prefer clean solid lines, I recommend you use hot pressed paper.

1 Use a wax crayon to draw any shape you wish onto your chosen paper.

2 Use your brush to paint a wash over the paper.

3 See how the wax crayon repels the watercolor.

Resist technique using white wax crayon.

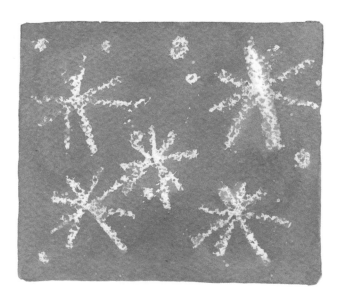

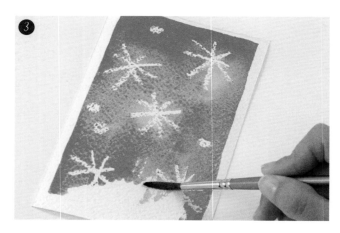

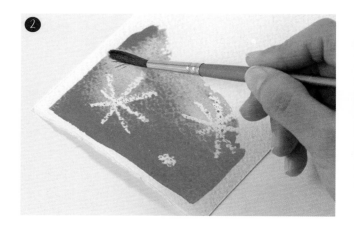

You can apply a wash first before drawing your design onto the paper (once dry), then add another layer of wash over the top. Try using crayons of different colors.

EXPERIMENTAL WATERCOLOR

WATERCOLOR PENCILS AND STICKS

One of the things that I like about watercolor painting is that it can be easily adapted to suit a person's skills or preferences. For example, I prefer working with my brushes directly on the paper. I have so much fun painting that drawing has taken a secondary place in my practice. However, I have found ways to use my watercolor pencils and sticks without drawing to achieve the unusual textural effects I love.

Watercolor sticks and pencils can be used to draw on dry or wet paper, of course, and sticks can even be used as a watercolor pan, but my favorite use for them is to create a powder to dissolve on my paper.

1 Wet your paper with water or a loose wash of color.

2 Use a knife to shave your watercolor stick on top of the wet paper. See how the powder dissolves on the paper to create an explosion of color, to give an effect that is almost like fireworks. Do not touch it – if you do it will dissolve completely and the effect will be lost.

Color powder explosion.

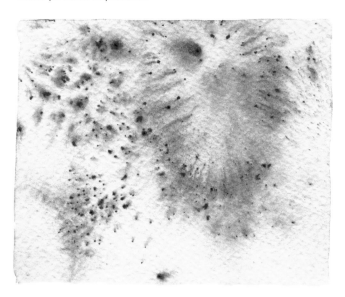

If you don't have a watercolor stick but want to have a go at achieving this effect, you could try using a watercolor pencil. The effect will be similar but more discreet.

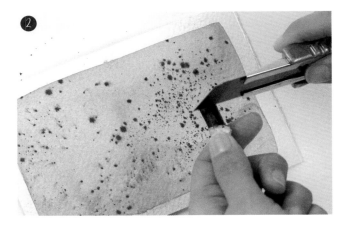

MIXED MEDIA PAINTING

We talk about 'mixed media' when we combine different art materials – watercolors, acrylics, oils, etc. – in our work. So, for example, a mixed media piece can be an artwork where we have used watercolor and acrylic, or watercolor and gouache, or watercolor and gel pens. This opens up lots of possibilities, from adding highlights to drawing patterns. You can create stars by splattering acrylic paint, or use a gel pen to cover little mistakes. It also means that you have an alternative for introducing white into your work if you don't want to reserve the white of the paper by using the masking fluid or wax crayon resist techniques. Just paint a wash, let it dry, then paint with acrylics or draw with gel pens over the top.

I have included some of my favorite media to use with my watercolors. You can explore your own choices, of course, but here is a list of things you need to consider first:

- Unless you are looking to create an unusual effect, it is better to make sure that your watercolor is fully dry before applying a new medium to your painting.

- To preserve the quality of your materials, keep other media away from your watercolor palette.

- Acrylics are permanent and when they dry, they are very difficult to remove, so never allow your brushes to dry with acrylic on them.

- You can apply acrylic on top of watercolor but watercolor cannot be applied on top of acrylic; once acrylic dries, it leaves a coat that will prevent the watercolor touching the paper.

WHITE ACRYLIC

This can be applied with a brush, or even a toothbrush. I love it because it has the quality of absorbing the color that is below, making a natural blend with the painting. If it feels too thick you can add some water to make it easier to apply. Remember that it is permanent, so once it dries on your paper it can't be removed.

GEL PENS

If you like drawing or scribbling, these are a great option. White gel pen looks more vibrant than white acrylic and making lines and adding small details can be much easier. Gel pens are water based, so if you don't like what you did, just dip a brush in clean water and remove it, but take care not to rub too hard or the watercolor will lift too.

GOLDEN PIGMENT

Gold can be found in different media, but my favorite is golden pigment in powder form because the finish is metallic. Golden pigment does need some preparation and every brand will suggest a different recipe. Another easier option is to use a watercolor ground in gold, which also has a metallic finish; the base is acrylic so refer to white acrylic for how to use.

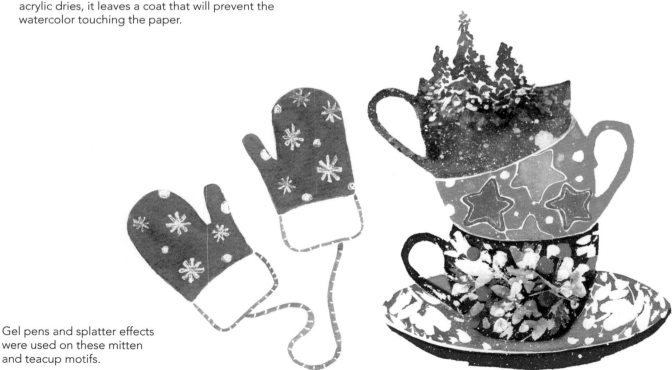

Gel pens and splatter effects were used on these mitten and teacup motifs.

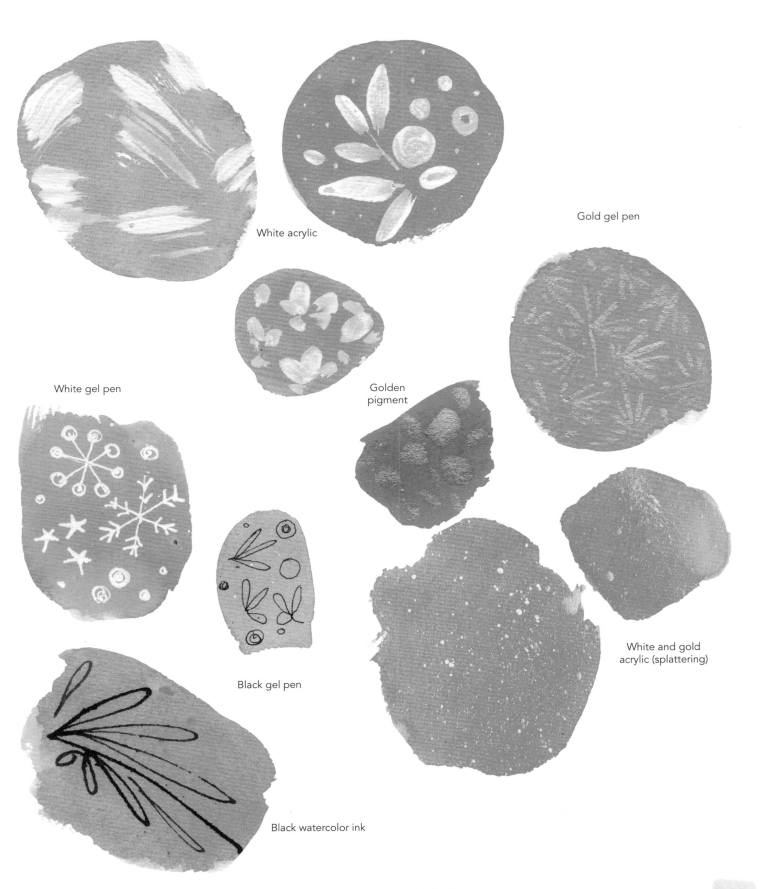

White acrylic

Gold gel pen

White gel pen

Golden
pigment

Black gel pen

White and gold
acrylic (splattering)

Black watercolor ink

EXPERIMENTAL WATERCOLOR

BEYOND BRUSHES

In the same way that unusual ingredients, like salt or alcohol, can complement and enrich our paintings, there are lots of everyday objects that can bring something completely unexpected to our artwork. Pictured here are just a few ideas for ways to make dynamic marks and interesting textures, but do experiment as the possibilities are endless.

Toothbrush: the stiffness of the bristles makes it perfect for splattering and for painting strong marks.

Tissue paper: when scrunched up into a ball, this can be used to lift off wet paint to create a cloudy effect.

Don't overdo it! Choose one or two techniques to create something unique on your paintings, but apply too many and it is easy to lose the surprise effect.

Cling film: press it into a wet watercolor wash and let it dry; when removed it will leave interesting patterns.

EXPERIMENTAL WATERCOLOR

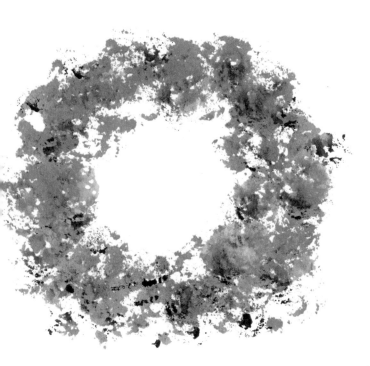

Natural sea sponge: dip the sponge into watercolor and press it to the dry paper to paint with texture.

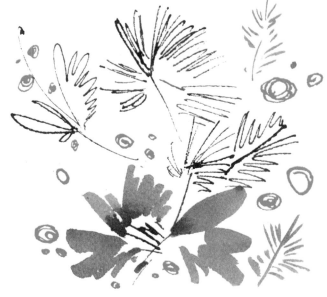

Bamboo or calligraphy pen: use these to draw fine lines with inks or watercolor inks.

Drips: use a dropper with ink or watercolor ink and let the drops expand on wet or dry paper.

Some of these techniques require confidence and dynamism, so before applying them onto a project, try them out first to fully understand how they work.

EXERCISE: STARRY NIGHT

This exercise explores how you can use the experimental techniques you have learnt in this chapter in your watercolor painting, by choosing your effects wisely. Be patient, allow the pigments to flow, and remember that some effects might need time to appear.

1 Prepare your colors. Use a pencil to draw simple pine trees and the outlines of the stars. Then use masking fluid to fill the stars and to draw over the lines of your pine trees. Leave to dry.

2 Once the masking fluid is dry, paint a wash to cover the entire area of your picture: starting from the top, wet your paper and change the colors as you move down.

3 Add a pinch of salt to the wash while it is still damp and, if you have a blue watercolor stick, shave a little powder on at the same time. Then leave your artwork to allow it to fully dry. Once completely dry, use a brush to paint the shapes of your trees around the masking fluid lines.

4 And use your brush to paint circles around the masking fluid stars too, to simulate light.

Once your painting is completely dry, do remember to rub off the masking fluid with your fingers and brush off any remaining salt.

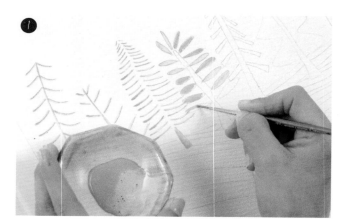

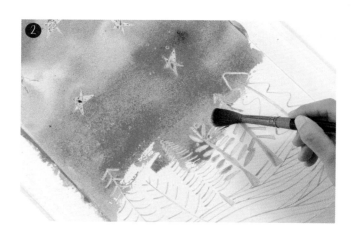

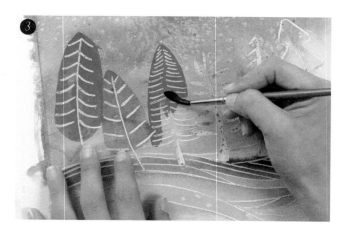

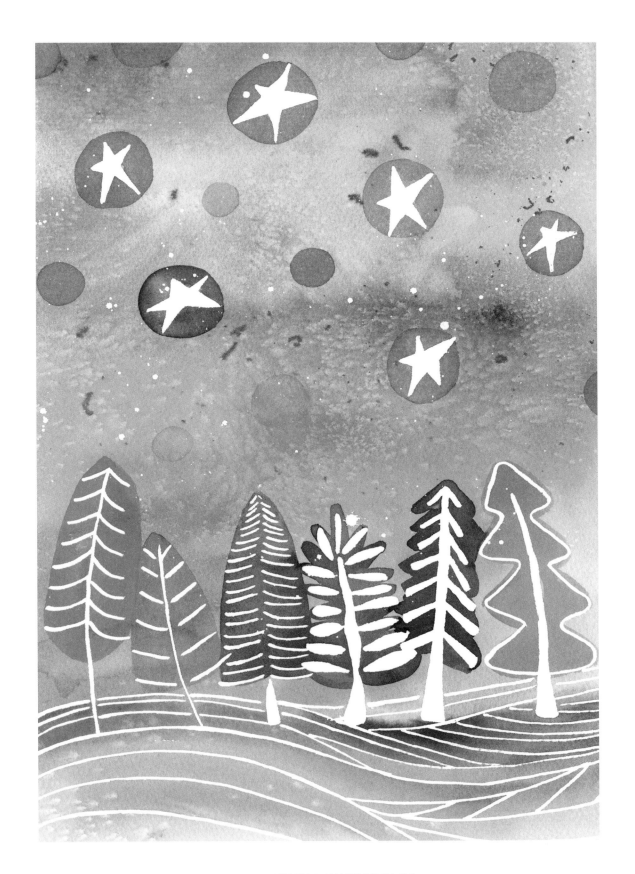

Project Preparation

Before starting any of the projects in this book, whether you choose one of the ideas from the Paper Projects section, where you are painting onto paper, or from the DIY Projects section, which includes ideas for painting onto other surfaces beyond paper, there are a few essential things to remember, as I've outlined here. Non-paper surfaces will require some special preparation, so I've covered this too!

TIPS BEFORE STARTING ANY PROJECT

- **Make a plan** Write down or sketch your ideas – whatever works best for you – about the theme, composition and color scheme of your work. Do avoid jumping straight in without a plan.

- **Prepare your supplies** This includes anything you will need to complete your painting, from choosing your paper and brushes, to preparing your palette. Remember that if you are using any of the techniques outlined in Experimental Watercolors, working with water limits the amount of time you have to apply alternative materials, so make sure you have anything you need – soap, salt, alcohol, etc. – to hand.

- **Design your color palette** That way you can focus on the task of painting instead of thinking what color comes next.

- **Try out your idea** You don't need to start working directly onto your expensive watercolor paper. I usually paint first on paper that is meant to be recycled. Remember, in the initial stages, we are just looking to develop an idea, to find the right brushes and explore color options.

Don't throw away your test pieces – there'll be a chance to use them for future projects!

PREPARING NON-PAPER SURFACES

While the traditional way to paint watercolor is on cotton paper, it can be successfully applied to any number of different surfaces, if they are prepared, and the easiest way to do this is by applying a watercolor ground. Watercolor grounds can be found in different colors, but if we want to replicate the effects achieved on cotton paper, white is the way to go, although I have also used golden ground for some of the projects. (Golden pigment ground is also great to use as a decorative medium, as described in Experimental Watercolor: Mixed Media Painting.)

APPLYING A WATERCOLOR GROUND

Most watercolor grounds can be applied to many different surfaces such as paper, glass, wood, metal, fabric and plastic. Some brands recommend sanding non-absorbent surfaces first, but I prefer to apply a coat of white acrylic paint instead. This is advisable for both absorbent and non-absorbent surfaces, especially if there is some color or pattern to be covered up, if recycling a set of tired coasters, for example.

After applying a coat of white acrylic and allowing it to dry, for best results you'll need to apply two coats of watercolor ground, allowing for drying time in between coats. Once the second coat has been applied, allow it to cure for at least 24 hours before beginning to paint with your watercolors.

From old place mats to recycled jars, almost everything has the potential to become a canvas. Also available are decorative blanks that can be bought specially to create handmade decorations and gifts.

A FEW IMPORTANT THINGS TO REMEMBER

Although a watercolor ground can make most surfaces feel like cotton paper, it still presents some limitations as far as working with the medium is concerned. For example, layering is slightly different than when working on paper because the pigments dissolve much faster on the watercolor ground, and for this reason, it is better to paint one layer only. This quality has some advantages, however: blending colors is easier and we don't need to work as fast as we do with paper!

Watercolor is a water based medium, so it is not advisable to paint onto surfaces that can potentially get wet or that may need cleaning. For this reason, recycling homeware objects such as coasters, trays or place mats, is only recommended if you can change their function: for example, a place mat could become a piece of wall art, or a tray, a dressing table tidy.

Watercolor is a very delicate medium and no matter what surface you are working on, it will need some care. For pieces we want to preserve for a long time, I recommend using a UV protection spray or an archival aerosol varnish.

To prepare a non-paper surface for painting, first apply a coat of white acrylic paint and let it dry.

Then apply two coats of watercolor ground; cure for 24 hours before painting with your watercolors.

Projects on Paper

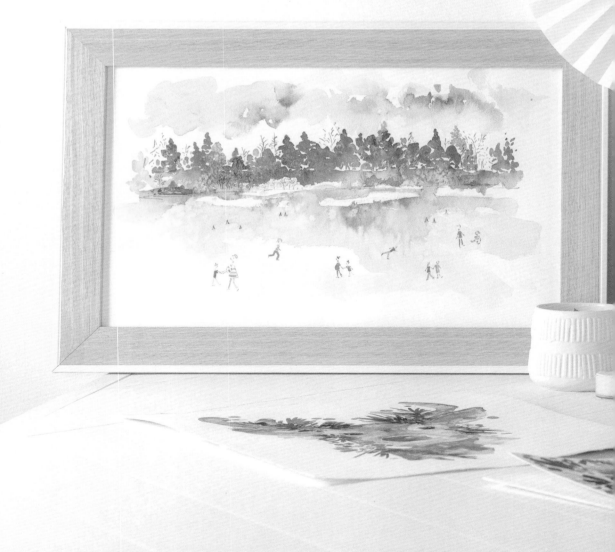

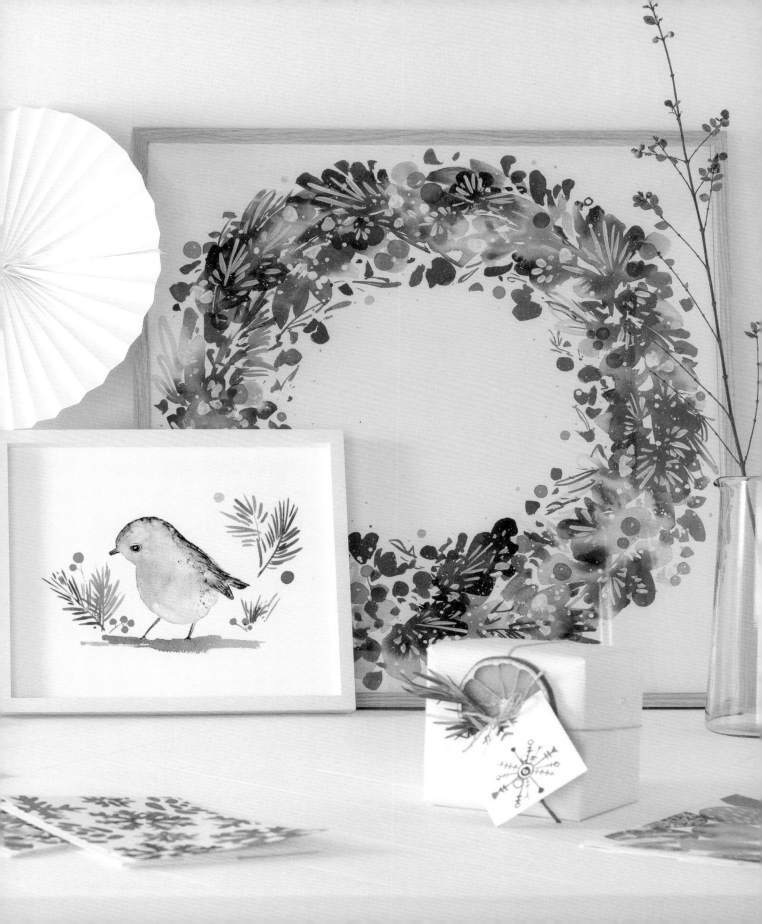

Creative Christmas Cards

Why not have a go at making your own postcard-style Christmas card collection? It's a great way to practice a whole range of watercolor tricks and techniques while perfecting some of the holiday season's best-loved motifs, from holly leaves to snowflakes, and candy canes to gingerbread men. Here are a few ideas to get you started, but do experiment to create your own combinations and develop your own designs. Just remember to prepare ahead, as you should before starting any project: make a plan – sketch out your ideas for your card theme, its composition and color scheme; prepare your supplies, including any alternative materials you'd like to try out; and design your color palette and test it first. Now let's get festive!

YOU WILL NEED

- Paper: see Materials and Equipment

- Brushes in a variety of shapes and sizes: see Materials and Equipment

- Other media of your choosing (e.g. white acrylic, inks, color pencils)

- Alternative materials of your choosing (e.g. table salt)

MY PALETTE

For details of the colors I have used, see the individual card designs.

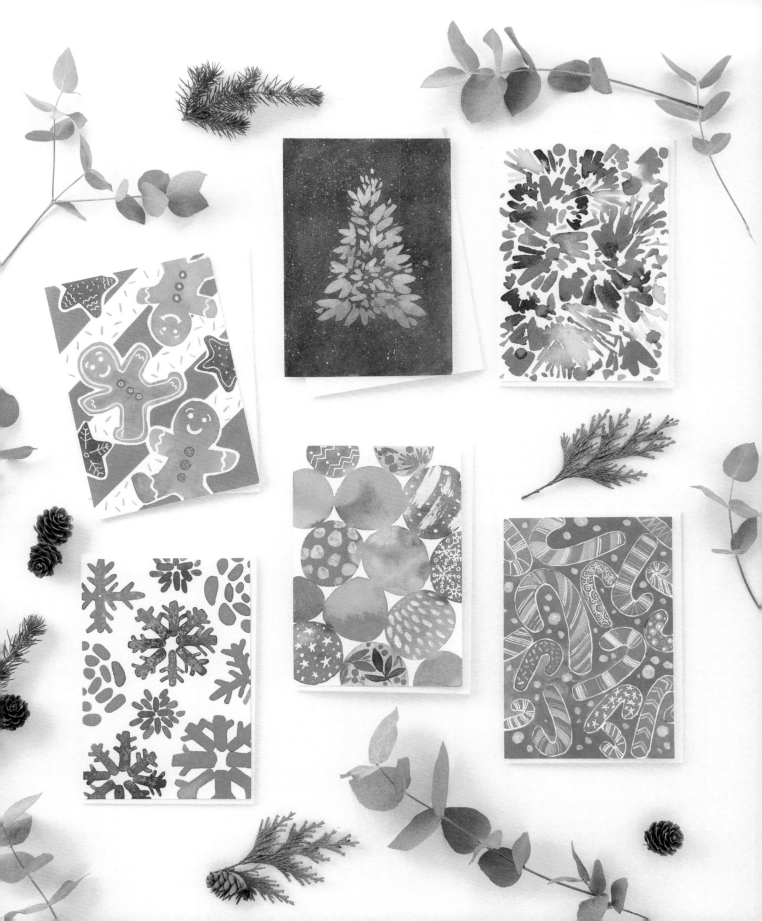

Bright Baubles

Here, the blending circles technique (see the Blending Circles exercise in Lines and Shapes) gives the impression of a box packed full of bright Christmas tree baubles. Many different colors have been used for the spheres and some have been decorated in a variety of ways.

MY PALETTE

Mixed from: Winsor Yellow, Green Gold, Phthalo Green, Cadmium Red, Cinnabar Red, Burnt Sienna, Cyan, Phthalo Turquoise, Prussian Blue, Indigo. To create a vibrant pink and enhance the purple, I added a drop of liquid watercolor, Cherry Red.

1 Paint a test first. Try out your color scheme and check if you like how the colors blend. Note the amount of water required; if the paper dries too fast, you might need to use more water.

2 Once you are happy, you can start your card design. Fill your paper with large circles using different colors. Work fast and allow the colors to blend naturally.

3 Once the paint has dried completely, use a white gel pen to draw Christmas motifs – stars, snowflakes, etc. – within some of the spheres. Continue to add patterns to some of the other spheres, using white acrylic for example. Experiment with different brushes or alternative materials to create textures.

4 Add leaves and berries to a one or two of the spheres using watercolors, inks or color pencils. To create some visual balance, leave a few of the spheres undecorated.

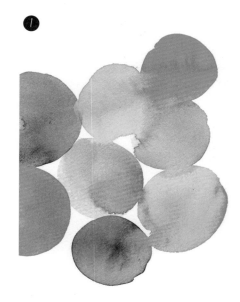

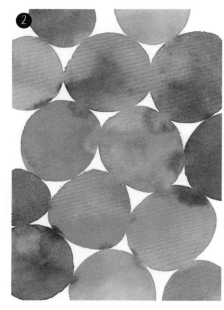

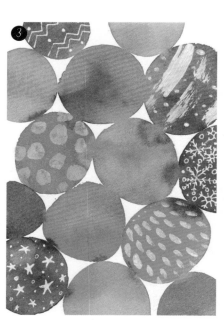

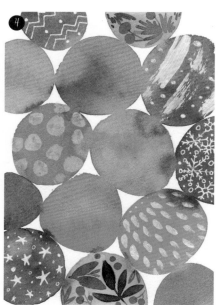

CREATIVE CHRISTMAS CARDS

Holly Leaves

For this card design, we are trying to capture the essence of holly leaves in a more playful way, using a loose freehand painting style and simple brush strokes. Working fast is essential if we want the leaves to blend with each other.

MY PALETTE

Mixed from: Prussian Blue, Indigo, Phthalo Green, Carmine Red. To create the vibrant greens, I added a drop of two liquid watercolors: Olive Green and Lemon Yellow.

1 Prepare your palette with a limited color scheme of blues and greens. Practice your brush strokes first using different brushes, until you are happy with the result.

2 Paint your first lines using just one color; remember that the pressure you add to your brush will have an effect on how thin or thick your leaves are (see Lines and Shapes: Painting Lines). Continue adding leaves while changing the color in your brush. Alternate from light green to deep blue to create some contrast.

3 If you wish to add some berries, paint some red dots while the paper is damp so they blend slightly with the surrounding leaves.

Once your painting is completely dry, remove the sheet from the block by tearing it from the glue-free corner.

Snowflakes

Do you know that there are 35 different shapes of snowflakes? I learned this fact while I was looking for some inspiration for my draw and fill snowflake card, but even so you might want to invent one or two of your own, just like I did!

MY PALETTE

Mixed from: Cyan, Phthalo Turquoise, Prussian Blue, Carmine Red. To create a vibrant turquoise, add a drop of liquid watercolor, Juniper Green.

1 First prepare your palette with two or three different shades of blue, green and purple. Then use a pencil to draw snowflakes to fill the paper (see Motif Gallery for some ideas).

2 Start to fill your first snowflake with one color; vary the tones or add a drop of a different color while it is still wet. Sprinkle on some salt if you wish (see Experimental Watercolor: Salt Texturing Technique).

3 Paint one snowflake at a time, taking the time to observe the effects achieved, for example, how colors react to the salt.

4 To get some visual balance, alternate color-effect snowflakes with salt-textured snowflake motifs. Let your snowflakes dry naturally.

If you want to explore a looser style for painting snowflakes, see Supercool Snowflakes.

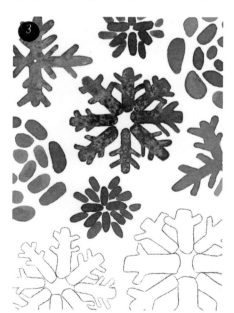
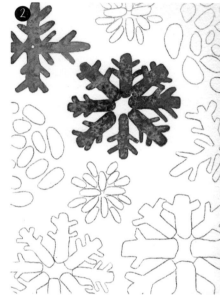
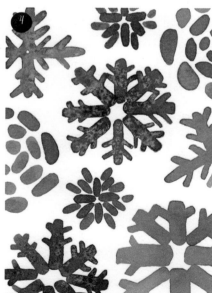

Christmas Tree

This card design allows us to practice the masking fluid resist technique and to explore layering. Before making a start, please read the instructions for preparing your brush for working with masking fluid (see Experimental Watercolor: Resist Techniques).

MY PALETTE

Mixed from: Cyan, Phthalo Turquoise, Intense Green and Indigo.

1 Paint a blended wash using the colors of your choice. I used Cyan, Phthalo Turquoise and Intense Green. When the paper is completely dry, paint on masking fluid with brush strokes that simulate the silhouette of a Christmas tree.

2 Once the masking fluid is completely dry, apply a flat wash of color to cover the whole page, and add an effect of your choosing: I added a pinch of salt and, when it had dried, I also splattered on some masking fluid using a toothbrush.

3 Once again, leave to dry, then add a second wash, preferably using a darker color: I used Indigo and added more salt while it was still wet. When we paint like this, every layer is an opportunity to add more effects.

4 Allow to dry, then remove the masking fluid and any remaining salt on the paper.

You can also try this technique with a white wax crayon, but remember that the crayon will affect the colors of your tree.

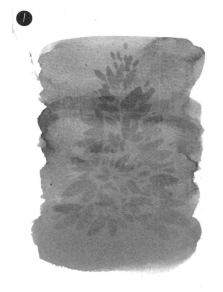

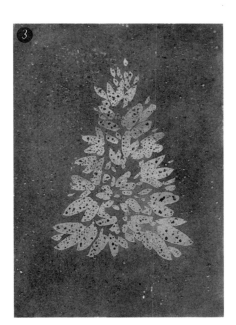

Candy Cane

The traditional candy cane is shaped like an inverted 'J', which is very easy to freehand paint using a round brush. This card design allows us to explore painting with white acrylic and gel pen. It is an interesting way to see how the white color in different media affects the watercolor when applied in layers.

MY PALETTE

Mixed from: Cadmium Red, Cinnabar Red, Carmine Red, Intense Green.

1 Use a round brush to paint the candy cane shape all the way across the paper, varying both its size and position, rotating the paper as you work.

2 Prepare white acrylic on a small plate: if it feels too thick, add some water, as this will make it easier to apply. Use your chosen brushes to paint line patterns in different thicknesses and angles within some of the candy cane shapes (I also used a dot pattern).

3 Decorate the remaining candy cane shapes with white gel pen using patterns or motifs of your choosing. Notice how the acrylic absorbs a little bit of the red color while the gel pen looks brighter.

4 You can leave your card as it is, or you can fill the background if you prefer. If painting the background, leave a white space around the candy cane shapes. You can leave the painted background as it is or add an effect: I chose to add white dots of varying size, using white acrylic, to simulate snow.

Gingerbread Men

Who doesn't love a gingerbread man? Baking these cookies at Christmas is a great activity to do with children and they make very nice gifts. You can choose to use the draw and fill technique for the gingerbread man motif, or simply paint them freehand, which is very easy to achieve with a round brush.

MY PALETTE

Mixed from: Burnt Sienna, Winsor Yellow, Carmine Red, Indian Red and Payne's Grey.

1 Use spare paper to practice the gingerbread man shape using a round brush, while you test your colors (I used Indian Red with a little bit of Winsor Yellow). Now paint, or draw and fill, your gingerbread men tumbling across the page. Once fully dried, decorate the gingerbread men using white acrylic or a white gel pen. (Note: I painted on the buttons using red watercolor first, then let them dry before adding the white detailing.)

2 To add the dark gingerbread stars, draw them first, then fill with brown watercolor (I mixed mine using Indian Red and Payne's Grey). Once the paint has fully dried, again use a gel pen or acrylic to add some details.

3 To prepare the card for the painting of the striped background, affix three strips of painter's tape on the diagonal, evenly spaced across the card. Paint the background with red watercolor leaving a white border around the gingerbread men and stars.

4 Let the background paint dry completely, then remove the tape lengths to reveal the white stripes. You can leave these as they are or add an additional element; I drew lines with color pencil to simulate sweet sprinkles.

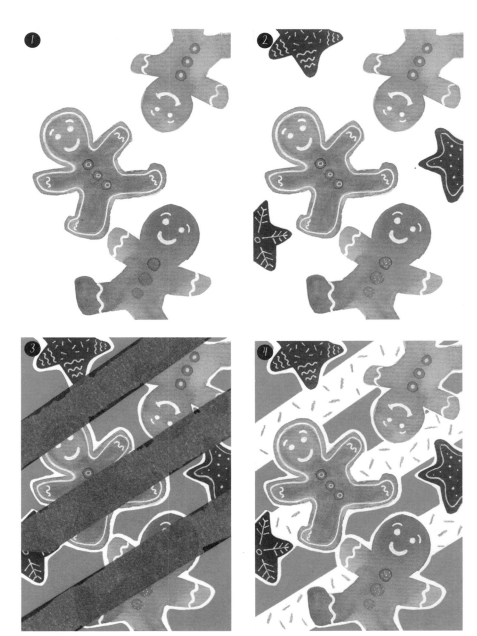

Winter Landscape

What kind of landscape comes to mind when you think about Christmas? I think about people ice skating. I grew up in Mexico where snow is something we only see in the movies. As a child I dreamed of building a snowman and of skating under the Christmas lights. I was 24 years old before I saw snow for the first time and it was many years later, when I was living in New York City, that I enjoyed the Central Park ice skating rink. Until this day, if I close my eyes and think about Christmas, I can still see the skaters in the park. This small painting is an interpretation of that memory.

YOU WILL NEED

- Paper: see Materials and Equipment
- Pencil and eraser
- Brushes: see Materials and Equipment
- Table salt
- Tissue paper

MY PALETTE

Mixed from: Phthalo Turquoise, Olive Green, Green Gold, Phthalo Green, Indigo, Payne's Grey, Carmine Red.

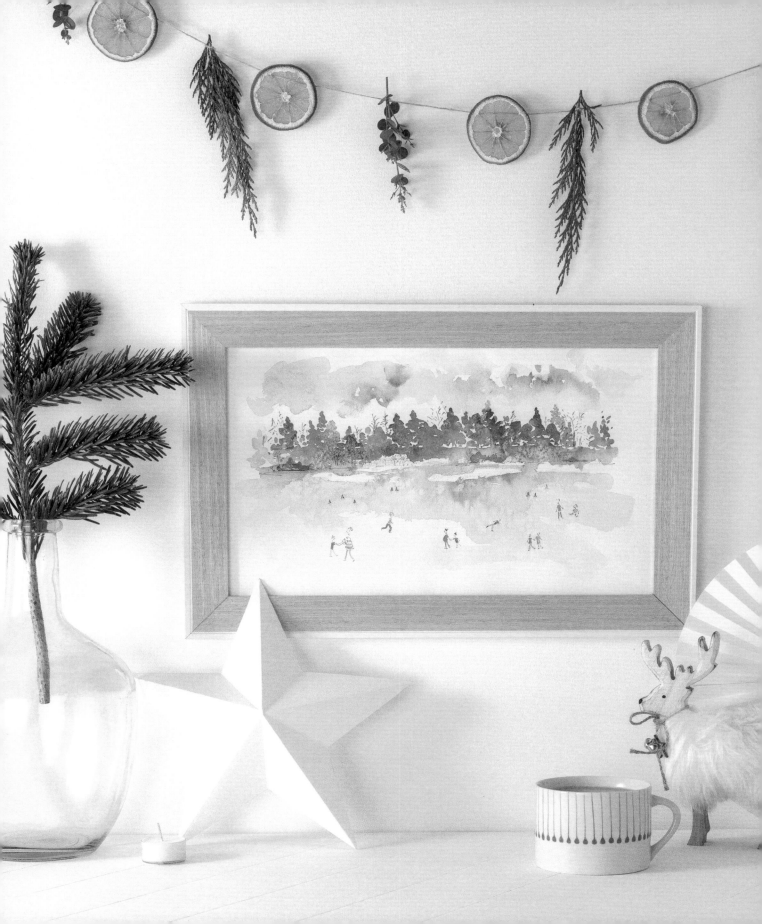

1 Starting at one side of the paper roughly at the center line, paint the shape of a pine in green, add a second then a third pine changing slightly the color in your brush each time. Allow the pines to touch and blend (see the Blending Circles exercise in Lines and Shapes). Continue painting pine trees and bushes in this way until you have a colorful line of them on the horizon.

Before they dry, paint the ice rink with a blue wash, letting the water touch the pines to create their reflection. Add a pinch of salt for texture (see Experimental Watercolor: Salt Texturing Technique) and leave to dry.

2 Once the watercolor paint is completely dry, use a pencil to draw on the skaters using just simple lines

without much detail. Think about their characteristics: are they children, or parents with their children; are they couples or individual skaters? If you wish to, add a few branches to the pines using a color pencil or a thin brush working dry on dry. I also drew on some small triangles for the safety cones distributed around the ice rink.

①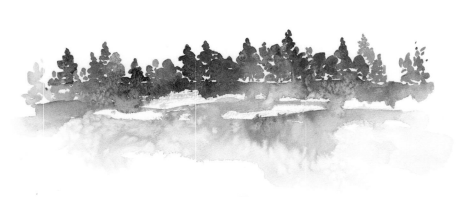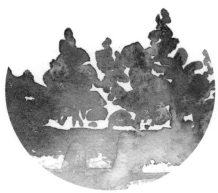

②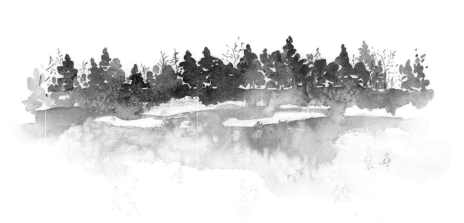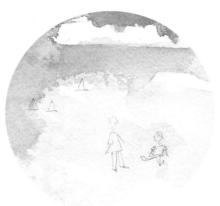

WINTER LANDSCAPE

3 Once the painting is fully dry, give your skating characters personality by adding color and small details in their clothes using watercolor or watercolor pencils. Add color to the safety cones too and create their reflection with inverted triangles using very diluted watercolor. Allow to dry, then finalize with a few additional details using a black gel pen; you will see that sometimes just a line or dot in the right place can become a scarf or a glove.

4 Decide how to finish your landscape. It could easily become a snowy scene by splattering white acrylic, but as I was very happy with the vibrancy of my pines, I decided to paint a bright blue sky instead. Paint a wash of Phthalo Turquoise and Indigo above the pines (but not touching them) and let it blend; to create a cloudy effect, lift some of the paint using scrunched-up tissue paper (see Experimental Watercolor: Beyond Brushes).

If it is too hard to imagine the skaters, look for photos on the internet and try to copy their basic forms. Think of how children draw people, just using lines and circles.

③

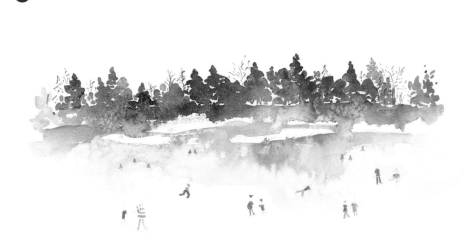

④

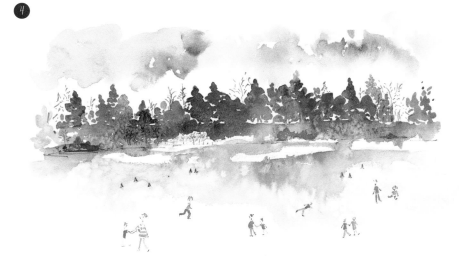

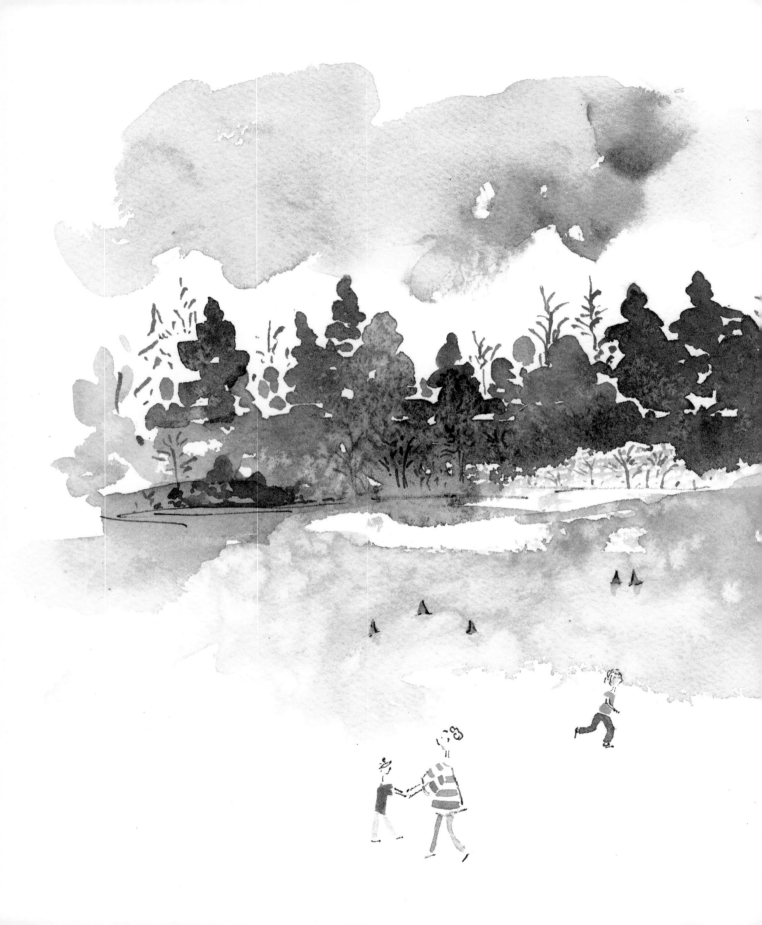

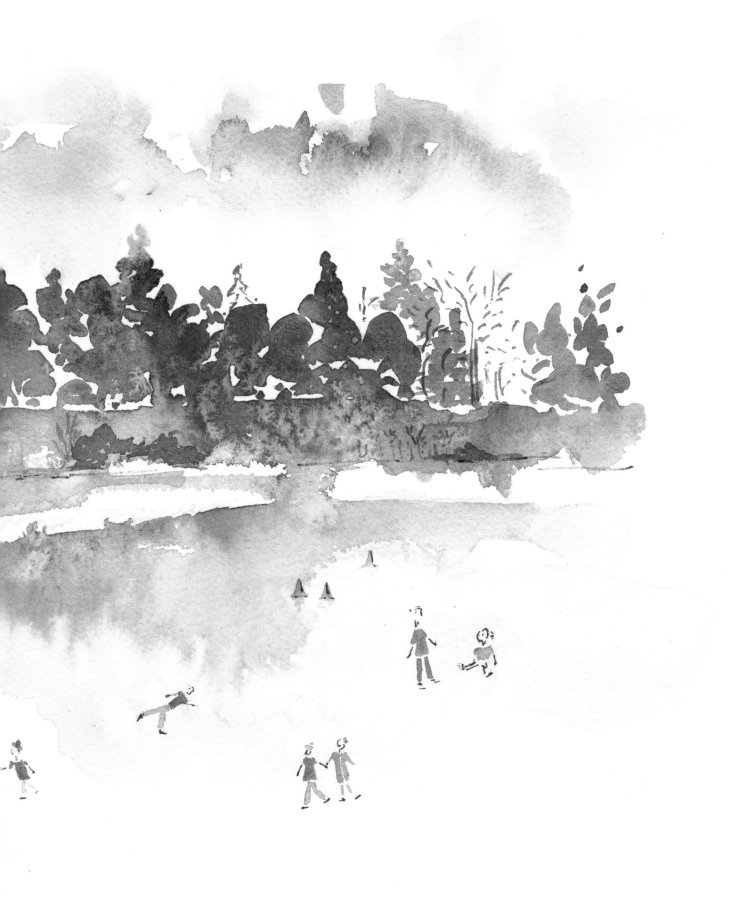

Traditional Wreath

A traditional Christmas wreath can be made from a variety of materials, from flowers and fruits to twigs and leaves, all woven together into a circle, and it is this that makes it such an interesting subject to paint. I love painting leaves and so, for this reason, I decided that my wreath would be decorated with evergreens and winter berries. If you are a beginner, I would advise you to paint the wreath branch by branch, as illustrated in my steps, but if you are an advanced water-colorist you can ignore this advice and paint the wreath as a continuous circle.

YOU WILL NEED

- Paper: see Materials and Equipment
- Pencil
- Plate or another circular object
- Brushes: see Materials and Equipment
- Toothbrush or brush with stiff bristles
- White acrylic

MY PALETTE

Mixed from: Intense Green, Olive Green, Phthalo Green, Indigo, Carmine Red.

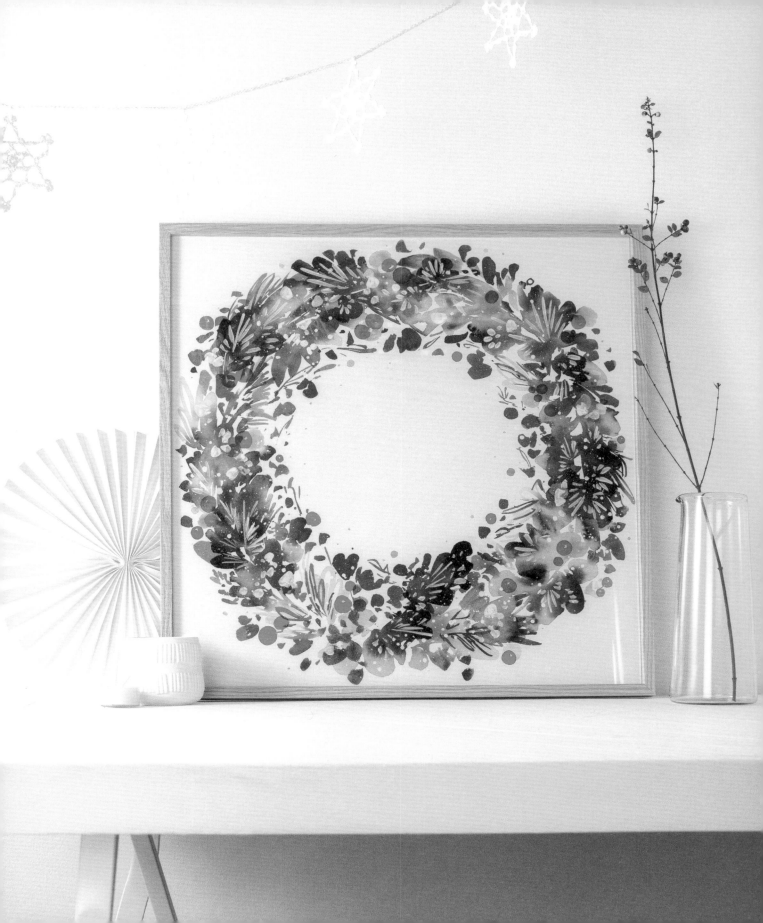

THE OVERVIEW

I have used the wet on wet technique (see Basics and Beyond: Washes and Textures) to paint this wreath. If you are a beginner, the process will be much easier if you paint it in sections, branch by branch, as illustrated here and as described step-by-step in Painting a Branch. If you have more watercolor experience, you can, of course, paint the wreath in one go, as long as you make sure to work fast enough to keep it wet during the process.

Start by marking out a circle, using your pencil to draw around a circular object such as a dinner plate. Paint the first branch following Painting a Branch, steps 1–4, then continue building from there, using the drawn circle as a guide to place the branches in the right direction.

Once the circle is complete and you are happy with the shape of your wreath, you can bring all the individually painted branches together by layering on a few extra touches (a smattering of snow, additional leaves and some bright berries), as described in Painting the Final Details, steps 5–7.

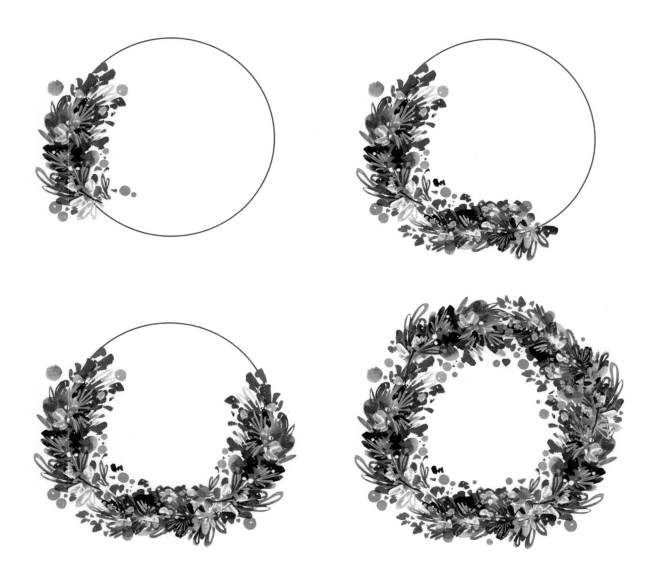

TRADITIONAL WREATH

PAINTING A BRANCH

1 Begin painting the general shape of your branch with a mix of diluted green and blue.

2 While it is still wet add additional leaves using a more concentrated green and let them blend for a minute.

3 Before it dries add another layer of leaves using a combination of green and indigo. Add one or two berries, too. Then allow it to dry completely.

4 Once it has fully dried add another layer of leaves using a more saturated green or indigo. The amount of pigment you use is important to gain some contrast between layers.

Before you begin, review Basics and Beyond: Lines and Shapes – Painting Lines. It is important to remember that here, our leaves are just lines and dots – try not to overthink the shapes.

PAINTING THE FINAL DETAILS

Once you have completed all the branches to form your wreath, it's now time to bring everything together, working around the wreath as a whole to add the white leaves, snow and berries; these elements help connect the individual branches that form the circle.

5 To create the effect of a sprinkling of snow, use a toothbrush or a brush with stiff bristles to splatter on white acrylic or white watercolor ink (see Experimental Watercolors: Mixed Media Painting).

6 Paint on a few more leaves all the way around the wreath, but this time using white acrylic.

7 Paint on more berries in different sizes using red; play with the amount of water and pigment to get different values as this will make your painting more interesting.

If you are using white acrylic and it is too thick, add water to dilute it and this will make it much easier to splatter.

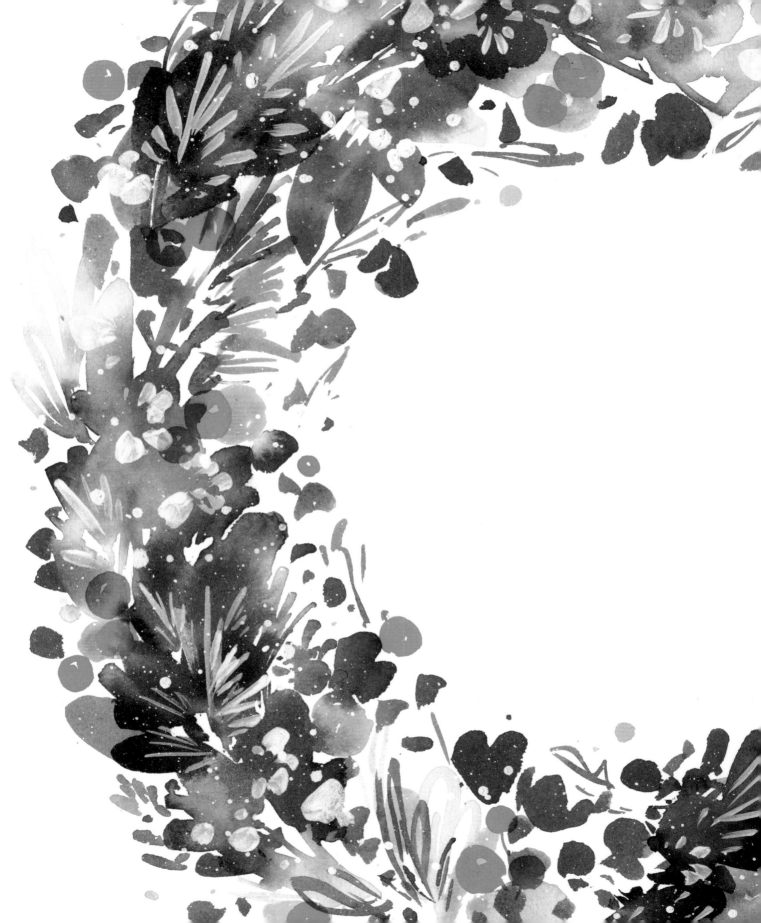

Evergreen Reindeer

Reindeer have become one the most popular animals of Christmas. They are said to represent journeying and endurance through travel, and it is perhaps for this reason that they became the inspiration for Clement Clarke Moore's poem 'The Night Before Christmas', where he describes for the first time Santa's reindeer-driven sleigh. Reindeer antlers are beautiful and because they resemble branches, it is easy to imagine all kinds of decoration entwined around them. I have been inspired by this idea to create a picture featuring evergreens and berries, created using blending and layering techniques.

YOU WILL NEED

- Paper: see Materials and Equipment
- Pencil and eraser
- Brushes: see Materials and Equipment
- Table salt or soapy water

MY PALETTE

Mixed from: Carmine Red, Indian Red, Burnt Sienna, Intense Green, Olive Green, Phthalo Turquoise.

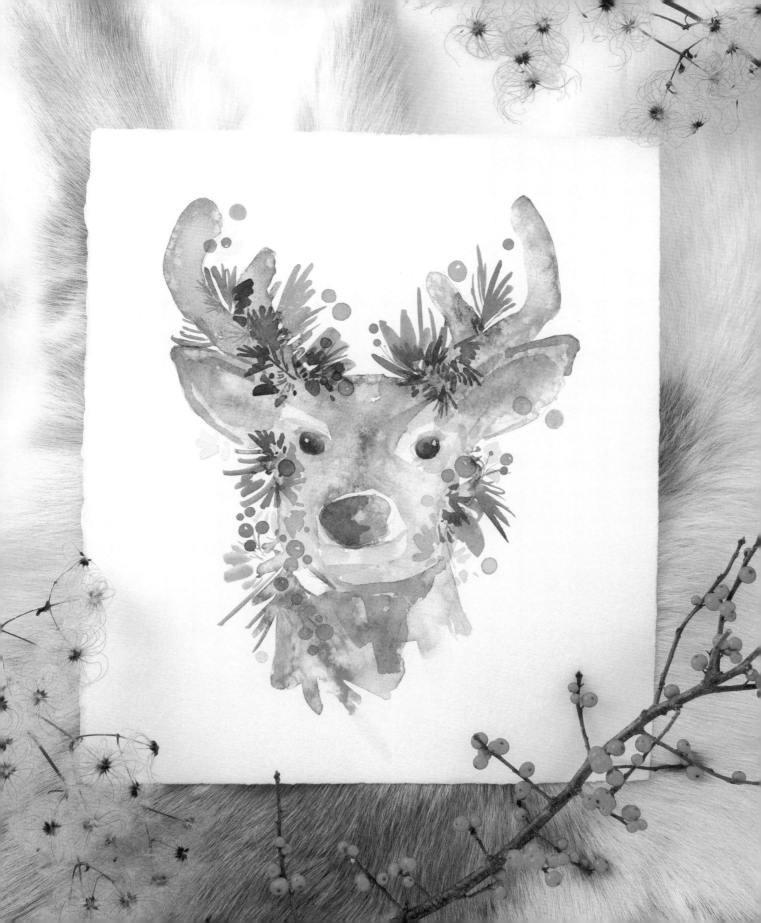

1 Use a pencil to draw the reindeer's head including the antlers. (I didn't draw any of the leaves and berries as I prefer to add them intuitively as I paint, allowing the greens to flow loosely.)

2 Using a mix of Indian Red and Burnt Sienna, fill the shape of the reindeer. Remember that the white areas are untouched paper; note how I have left some space around the eyes and nose. While the painted reindeer is still damp, add the first leaves using different shades of green and blue, and allow the colors to blend. Add a pinch of salt or splatter on some soapy water to create some texture (see Experimental Watercolor).

3 Once this layer is completely dry, add details to emphasize the shape of the reindeer's ears and nose. Paint the reindeer's eyes and add a second layer of leaves. Note how by working over dry layers, we can take full advantage of the transparent quality of watercolors, to achieve sharper details and give more depth to our painting. Allow this layer to dry completely before continuing.

4 The last layer is all about adding detail. I painted red and purple berries all around, and you can add more leaves if they are needed. I finished my picture by splattering it with green watercolor, using the bristles of my brush for a more dynamic effect.

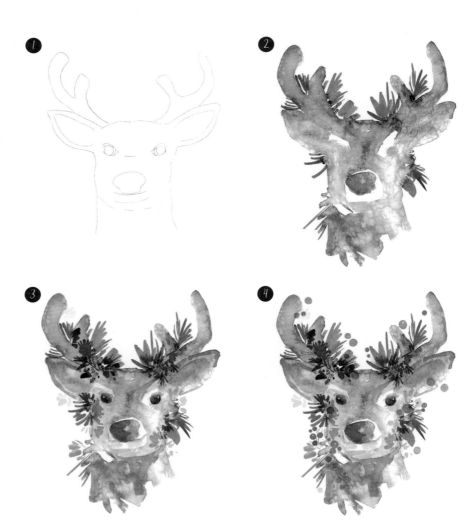

For more ideas for using alternative materials to add texture to your work, see the Experimental Watercolor chapter.

EVERGREEN REINDEER

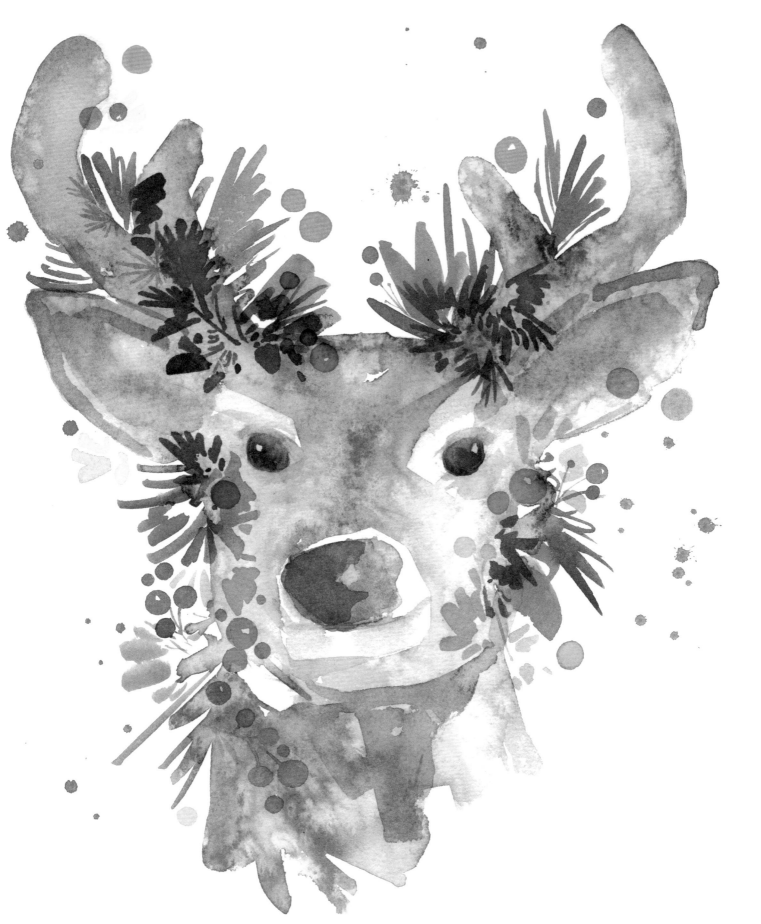

Robin Red-Breast

The robin is a popular motif on British Christmas cards, which may have something to do with the fact that during Queen Victoria's reign, the postmen wore red coats and were nicknamed 'robins'. Perhaps that is why they have become so firmly associated with the delivery of seasonal greetings, or perhaps it is because they are one of the few British birds that don't migrate in winter and their birdsong can be heard throughout the festive season. This beautiful red-breasted bird is easy to achieve by combining the techniques of blending and wet-on-dry, and a card or picture featuring one is sure to delight a bird-loving friend.

YOU WILL NEED

- Paper: see Materials and Equipment
- Pencil and eraser
- Brushes: see Materials and Equipment
- Alternative materials of your choosing (e.g. table salt)

MY PALETTE

Mixed from: Winsor Yellow, Cinnabar Red, Burnt Sienna, Payne's Grey, Cyan.

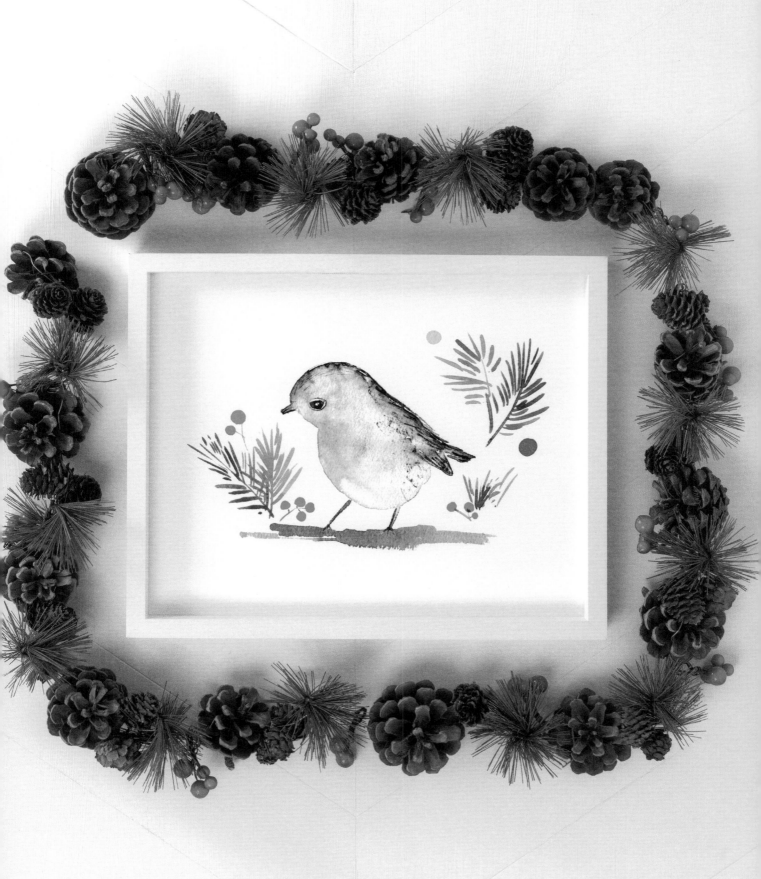

1 Use a pencil to draw the outline of your robin very lightly. Starting from the bottom, paint half of the robin with a translucid wash of yellow and from the top with a wash of gray, and allow them to touch so that the colors blend.

2 While still wet, add with the tip of your brush a mix of Cinnabar Red, Burnt Sienna and Winsor Yellow. The mix of colors in your brush doesn't need to be even; remember that when the paper is wet enough the pigments will dissolve and mix with the wash.

3 Let your bird painting rest for a minute or two, then before it dries, darken the head, wings and legs by applying Payne's Grey with a thin (#0) brush. If you wanted to get some texture, this would be a good time to add a pinch of salt (see Experimental Watercolor: Salt Texturing Technique). For additional contrast, apply a touch of Cyan beneath the wing.

4 Once completely dry, use a thin brush to paint the details of the eye and beak. To make the wings more interesting, take some gray on a dry brush and paint some rough lines to give the suggestion of feathers. Erase any visible pencil marks.

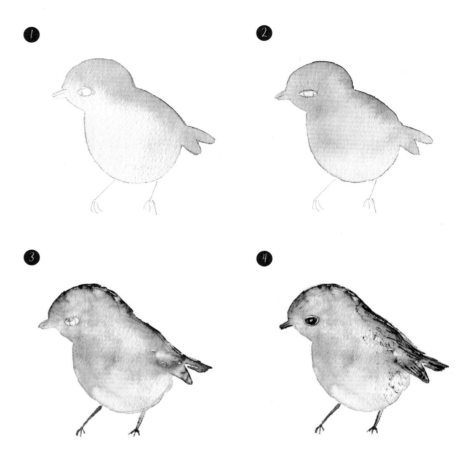

Once your robin painting is complete, you can paint a branch for it to perch on, and add a few seasonal sprigs if you choose to.

ROBIN RED-BREAST

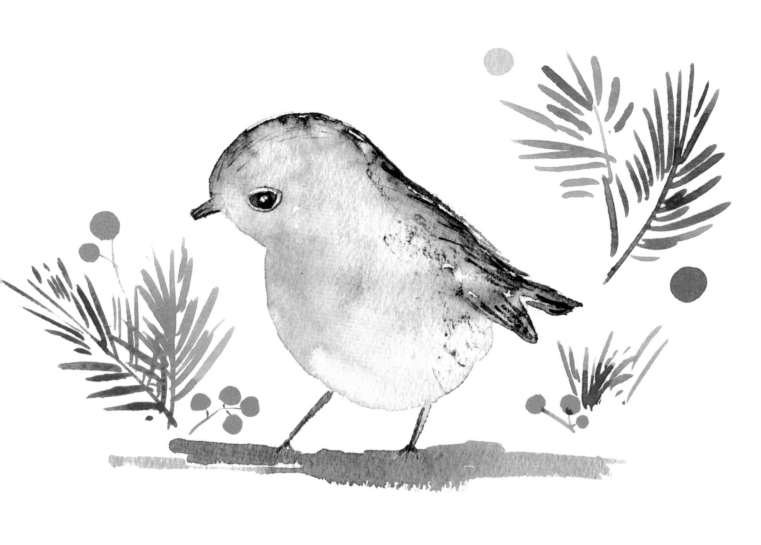
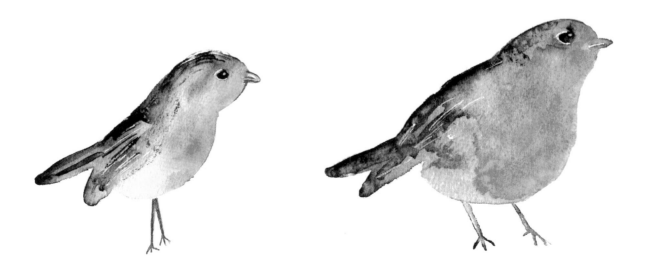

ROBIN RED-BREAST

Supercool Snowflakes

When I wrap presents, and even when I prepare deliveries for my customers, I always add a tag or a thank-you note. For years I bought special tags to do this, until I realized how many painted samples I had around my studio that I could use for this purpose! For this project, I've had fun filling two sheets with snowflakes, while experimenting with watercolor inks. My snowflake tags are so vibrant because I used watercolor inks from Dr. Ph. Martin's, but a similar effect can be achieved using very concentrated watercolors.

YOU WILL NEED

- Paper: see Materials and Equipment
- Brushes: see Materials and Equipment
- Pencil and ruler
- Box cutter
- Hole punch
- Cord

MY PALETTE

Mixed from: Slate Blue, Juniper Green and Ultra Blue (watercolor inks from Dr. Ph. Martin's).

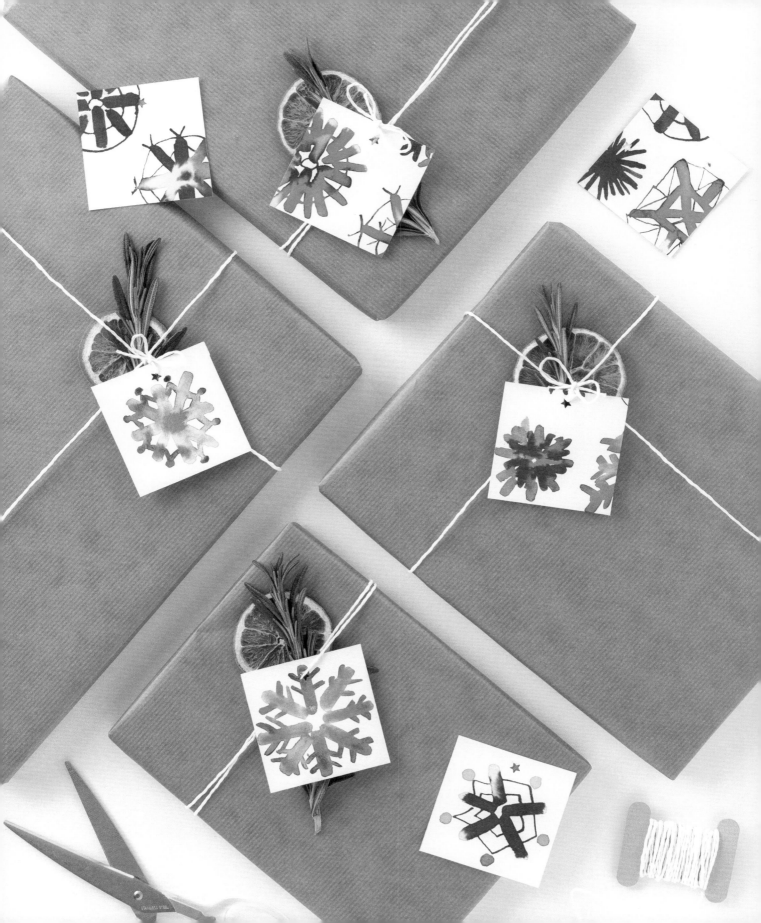

PAINTING THE SNOWFLAKES

1 Prepare your palette with a mix of different shades of blue, making them very watery to encourage some exciting blending as you work. Start to paint different snowflake shapes with your brushes.

2 Alternate between a medium and a thin brush to get different line thicknesses on some of your snowflakes.

3 If a snowflake looks very translucid, you can add a drop of ink or concentrated watercolor while it is still wet, then allow the pigments to flow and blend naturally.

4 You can use the tip of the pipette to draw fine lines on dry sections of the paper to join your brushstrokes to make a snowflake motif. Usually the ink in the tip is enough, so there is no need to squeeze it!

5 Once you have filled your sheet with a variety of snowflakes, let your painting dry completely.

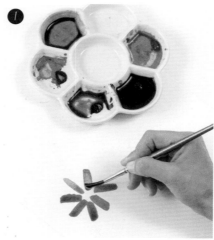

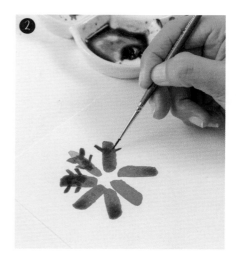

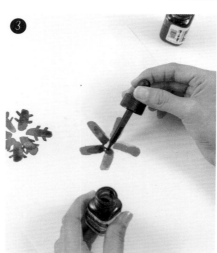

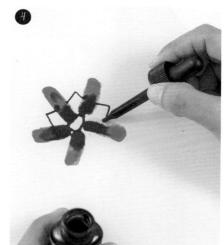

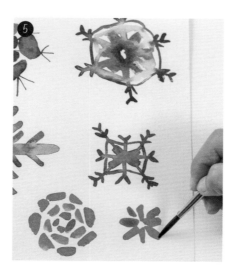

This is a great way to make use of leftovers from other watercolor projects, including test swatches or even old sketches.

MAKING THE TAGS

6 Choose the areas of your snowflake painting that you most like and use a pencil and ruler to draw out the shape of your tags.

7 Use a box cutter and metal ruler to cut out the marked out tags cleanly.

8 Use a hole punch to make holes for the cord (I used a star-shaped hole punch that I had, but a circle punch is fine too). Slip a length of cord through the hole ready to tie each tag to a gift.

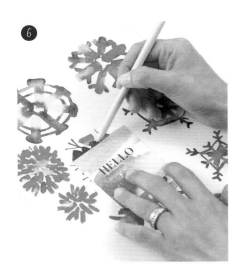

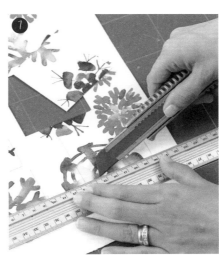

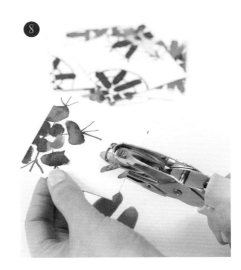

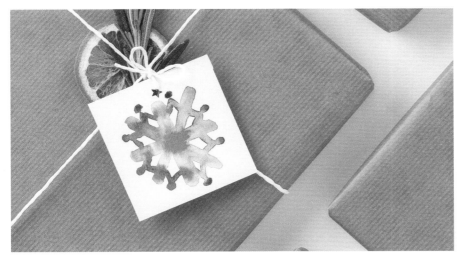

When marking out and cutting your tags, use an existing tag as a guide – I used my business card!

DIY Projects

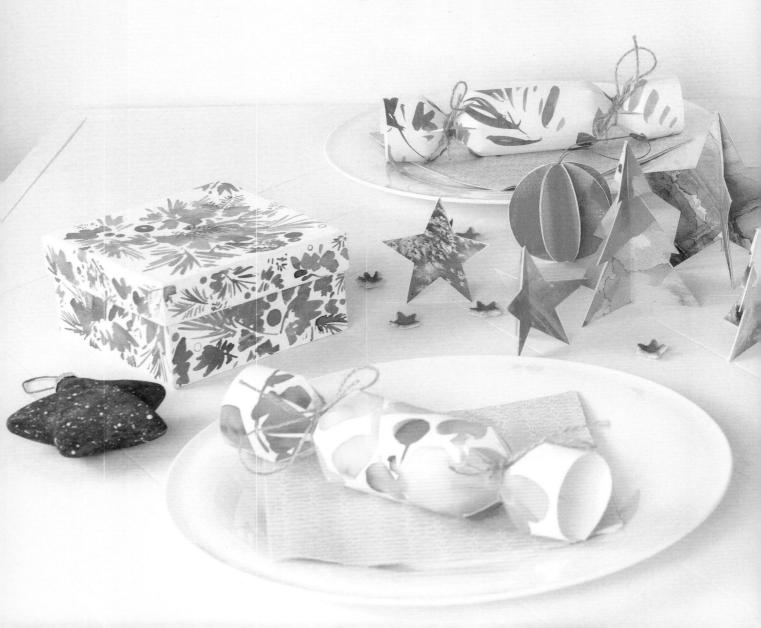

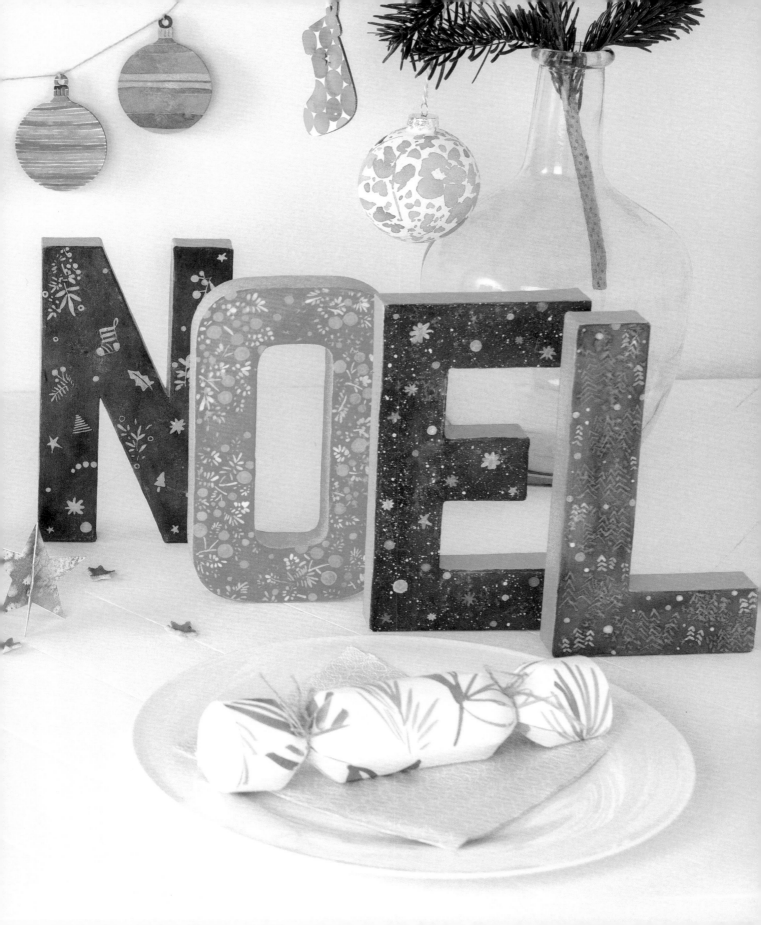

Little Stockings

The fun part about creating our own Christmas decorations is that we can pick any of our favorite traditions and adapt them to our personal needs and preferences. I have always loved the tradition of hanging a stocking on the mantelpiece at Christmas and when I found these little wooden ornaments at my local art store, I realized that the lack of a fireplace was no longer a problem! They can be hung as ornaments from the Christmas tree, strung to make a window garland, or personalized to make unique gift tags. There are all sorts of ways to decorate them, and friends and family can help too.

YOU WILL NEED

- Watercolor ground in white and gold
- White acrylic
- Brushes: see Materials and Equipment
- Gel pens in white, gold or silver
- Wooden stockings readily available from art and DIY shops

MY PALETTE

Mixed from: Cadmium Red, Cinnabar Red, Burnt Sienna, Indian Red, Intense Green, Phthalo Turquoise.

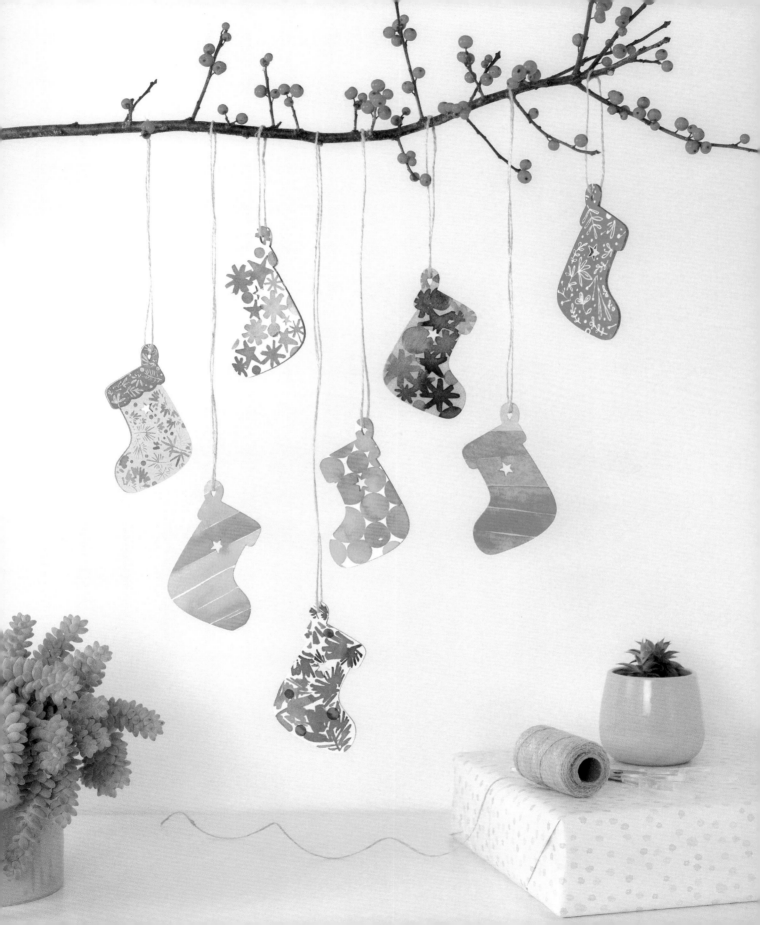

PREPARING THE STOCKINGS

1 Paint one side of all your shapes with a coat of white acrylic and allow to dry; then paint the other side. Once dry, paint with white watercolor ground, although you could also use gold on a couple, for variety, if you choose to. For best results, leave for 24 hours to cure.

DECORATING THE STOCKINGS

2 Blending elements Start by painting a circle, star or any other shape of your choice onto the stocking, followed by a second shape. Allow them to touch slightly so the colors can blend.

3 Continue to fill the stocking with more shapes; change the color each time or play with transparency by adding more water.

4 Gel pen decoration Paint your stocking with a solid color and allow to dry. Decorate the painted stocking using white, gold or silver gel pens (see Experimental Watercolor: Mixed Media Painting). (If you prefer to paint your decorations on, I recommend you use a thin brush and acrylic paint.)

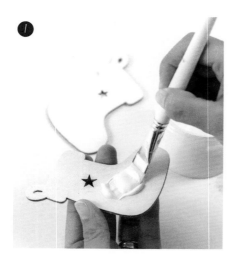

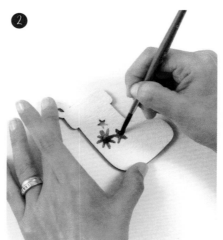

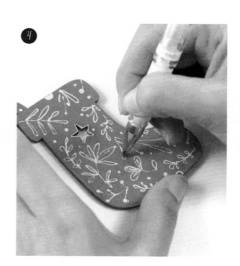

While you are waiting for the stockings to dry, plan your theme and practice strokes and colors by working first on paper.

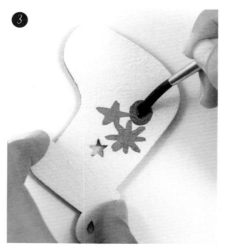

Some watercolor effects will behave slightly differently on watercolor ground than on watercolor paper so do review Basics and Beyond: Project Preparation to know what to expect.

5 Botanicals Refer to Lines and Shapes: Using Lines to Paint Botanicals, but remember our working surface is so much smaller here than when we are painting our botanicals onto paper, so we'll need to work with a thinner (#0) brush. Keep the shapes of your leaves very basic, using just a line or two.

6 Use different shades of green for the leaves and complete with a few red dots for the berries.

7 Diagonal stripes Paint a diagonal stripe using any color of your choice. Before it dries, paint another one, changing slightly the value of the color used (or changing the color altogether), and continue in this way to fill the stocking shape. Each new stripe needs to be painted very close to the previous one; sometimes they will touch and that means that the colors will mix effortlessly creating new and interesting blends.

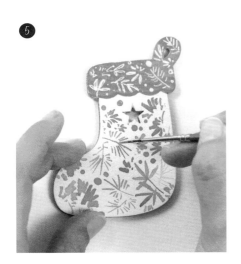

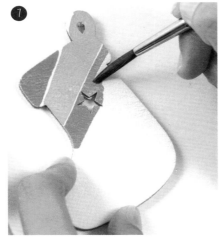

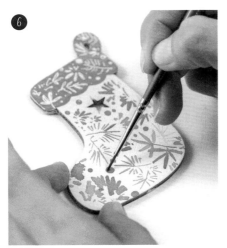

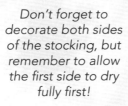

Don't forget to decorate both sides of the stocking, but remember to allow the first side to dry fully first!

Festive Letters

A festive message on your hall table can be the perfect way to welcome your guests at Christmas. I've chosen to spell the word 'NOEL', which, according to etymologists, has many different meanings including 'good news', 'birth' and 'a carol', and 'The First Noel' is still one of the best-loved songs of Christmas. Letters made from papier-mâché or wood are easy to source and only need be prepared with watercolor ground before decorating. I used different colors and details for each of my mine, so that each letter has its own personality within the group, but the basic decorating technique is the same. What will your message be?

YOU WILL NEED

- White acrylic
- Watercolor ground in white and gold
- Papier-mâché or wooden letters readily available from art and DIY shops
- Brushes: see Materials and Equipment
- Toothbrush or brush with stiff bristles
- Table salt

MY PALETTE

 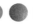 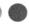

Mixed from: Prussian Blue, Cinnabar Red, Payne's Grey, Phthalo Green.

PREPARING THE LETTERS

1 Paint each of the letters with white acrylic, working over the whole of the letter, then allow to dry. Once completely dry, apply a thick coat of white watercolor ground only on the areas you intend to paint with watercolor (I have painted the front and the sides). Let dry for a couple of hours, then apply a second coat and leave to cure for 24 hours.

DECORATING THE LETTER 'N'

2 Paint the front of the letter with a wash of Prussian Blue.

3 Drop on a pinch of salt for texture (see Experimental Watercolor).

4 Allow the salt time to react with the paint before deciding whether to add more. When you are happy with the effect, allow to dry.

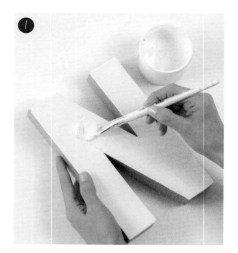

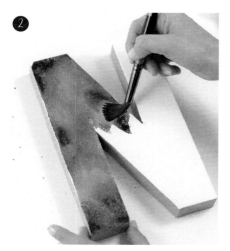

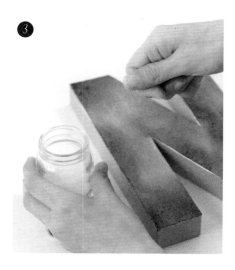

FESTIVE LETTERS

5 Once dry, paint on a second layer of blue to make the color more intense. Feel free to add another pinch of salt if you want a more intense starry effect.

6 Using a thin brush (#0) and golden watercolor ground, paint simple Christmas motifs such as stars, holly leaves and berries, evergreens, trees and candy canes.

7 Paint the sides of the letter. I've used golden watercolor ground but you could use any color of your choice.

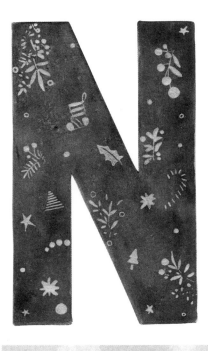

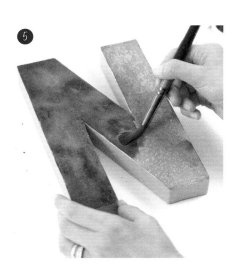

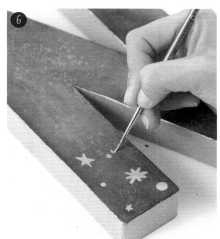

You can choose to skip step 5 if you are happy with your first layer of color.

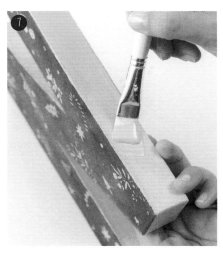

If the golden watercolor ground feels too thick, add water to dilute it to make it easier to apply. Alternatively, use a gold gel pen or a mix of golden pigments prepared with a watercolor medium.

DECORATING THE LETTER 'O'

8 Repeat steps 1–5 of letter 'N' but this time use a wash of Cinnabar Red. Paint leaves and berries with a thin brush, using white acrylic for the leaves and gold paint for the berries. Once dry, paint the sides of the letter (see letter 'N', step 7).

DECORATING THE LETTER 'E'

9 Prepare a mix of Payne's Grey and Prussian Blue and repeat steps 1–5 of letter 'N'. Once dry, decorate the letter with stars and dots painted in white acrylic and gold paint using a thin brush. Let dry, then use a toothbrush or a brush with stiff bristles to splatter white acrylic all over.

10 Once dry, review the decoration. and add a few more motifs if necessary. Let dry, then paint the sides of the letter (see letter 'N', step 7).

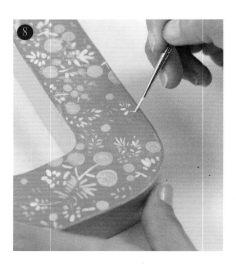

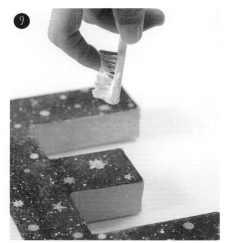

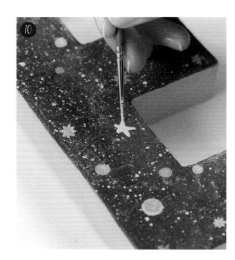

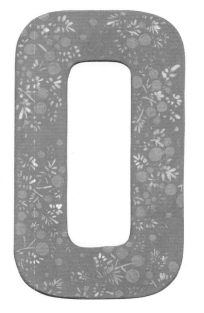

When working with golden pigments, the water used to rinse the brushes becomes sparkly. If you use that water to paint the washes you'll get a lovely golden effect.

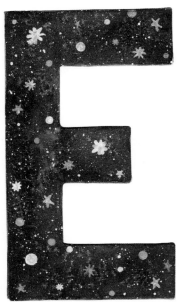

DECORATING THE LETTER 'L'

11 Repeat steps 1–5 of letter 'N' but this time use a wash of Phthalo Green. Once dry, paint the decoration. For the pines, use simple chevron line patterns in white acrylic and gold paint.

12 To give the impression of a snowy landscape, fill any spaces in between the pines with white dots. Once dry, paint the sides of the letter (see letter 'N', step 7).

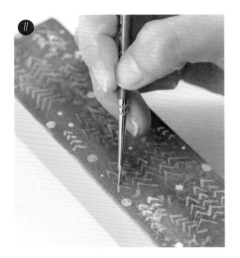

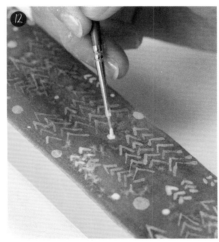

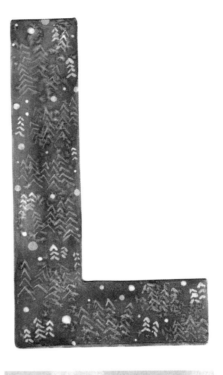

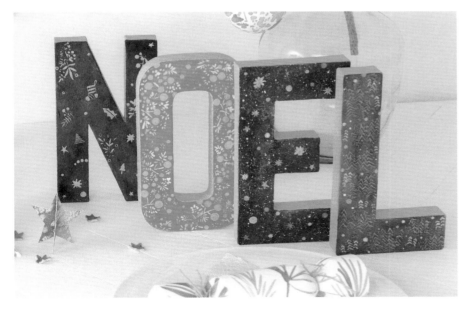

If you want to change the effect on one of the letters, it's easy to remove the watercolor using a wet brush and a paper towel, although it may be necessary to apply a fresh coat of watercolor ground before starting over.

Party Crackers

No British Christmas party is complete without the pulling of a cracker to win a treat, a paper crown and a joke or a riddle. This tradition dates back to Victorian times, yet is unheard of almost everywhere else in the world! Why should that be, when crackers are so easy to make? Simply roll a paper sheet into a tube, fill with treats and twist and tie at both ends. Now paper is something we artists have a lot of lying around the studio, and if you have been following the exercises in Basics and Beyond, you will probably have a good number of practice pieces yourself. This is the perfect project to give them a new purpose.

YOU WILL NEED

- Practice pieces approx. 8¼in x 11¾in (210mm x 297mm)
- Cord or ribbon
- Treats of your choosing
- Box cutter and ruler
- Pencil

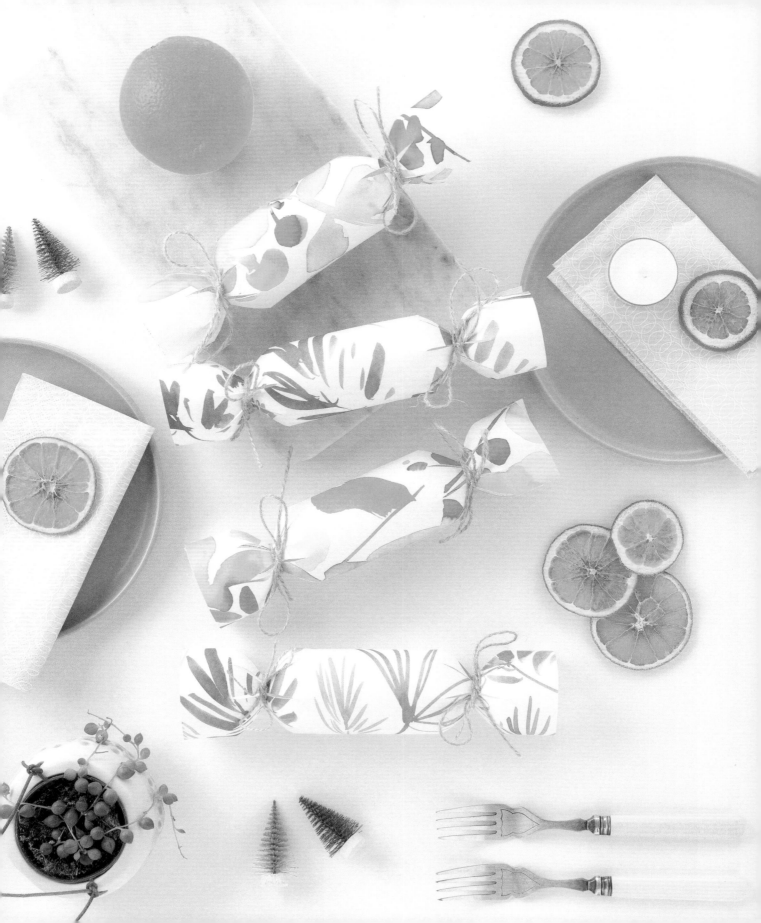

1 For this project I am using some student grade paper sheets that I used to practice my leaf brushstrokes (see the Lines and Shapes chapter for similar exercises), and a floral watercolor sketch that has been around the studio for a while. Using the cracker template, either scan it and print it directly onto your paper (if your printer allows you to use thicker paper), or make a copy of it and transfer it onto your paper using tracing or carbon paper. Using a box cutter and a ruler, cut out the template by cutting over all the marked lines.

2 Roll up the cut out cracker and insert the tab into the slit at one side.

3 Use a length of ribbon or cord to tie up one end of the cracker.

4 Fill the cracker with your chosen treats, then use a second length of ribbon or cord to tie up the other end.

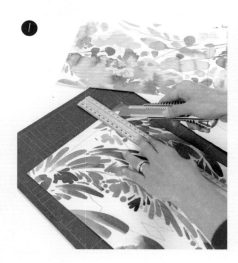

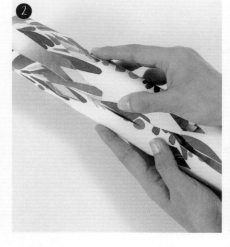

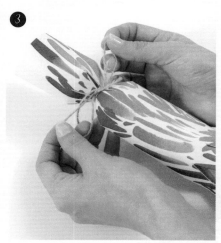

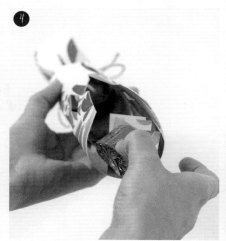

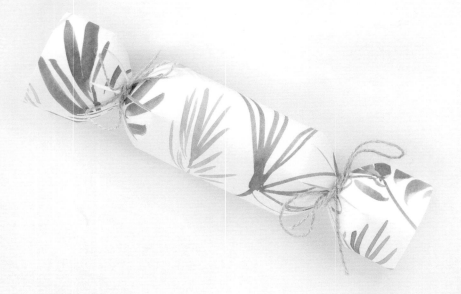

When two people pull at either end of the cracker, the treats inside will be released. With shop-bought crackers this is usually accompanied by a bang, and cracker snaps can be bought online if you want the same effect.

PARTY CRACKERS

Cracker template: this
can be enlarged when
scanning if you prefer
larger crackers.

Keepsake Boxes

What better way to make your Christmas presents extra special than gifting them in hand painted boxes to match the theme of your home decorations this festive season? You can buy box blanks in many different shapes and sizes from art and DIY shops, but any standard box can be prepared for painting using watercolor ground. This is the perfect project to repurpose old shoe boxes or packaging saved throughout the year. Your collection can include some where the lid only is decorated, using a plain color on the base, or others where the whole box is painted. I've given you a couple of design ideas to get you started but I know you will have fun coming up with others of your own.

YOU WILL NEED

- Watercolor ground
- White acrylic
- Boxes to be decorated
- Brushes: see Materials and Equipment

MY PALETTE

Mixed from: Winsor Yellow, Intense Green, Olive Green, Cyan, Phthalo Turquoise, Prussian Blue, Cinnabar Red.

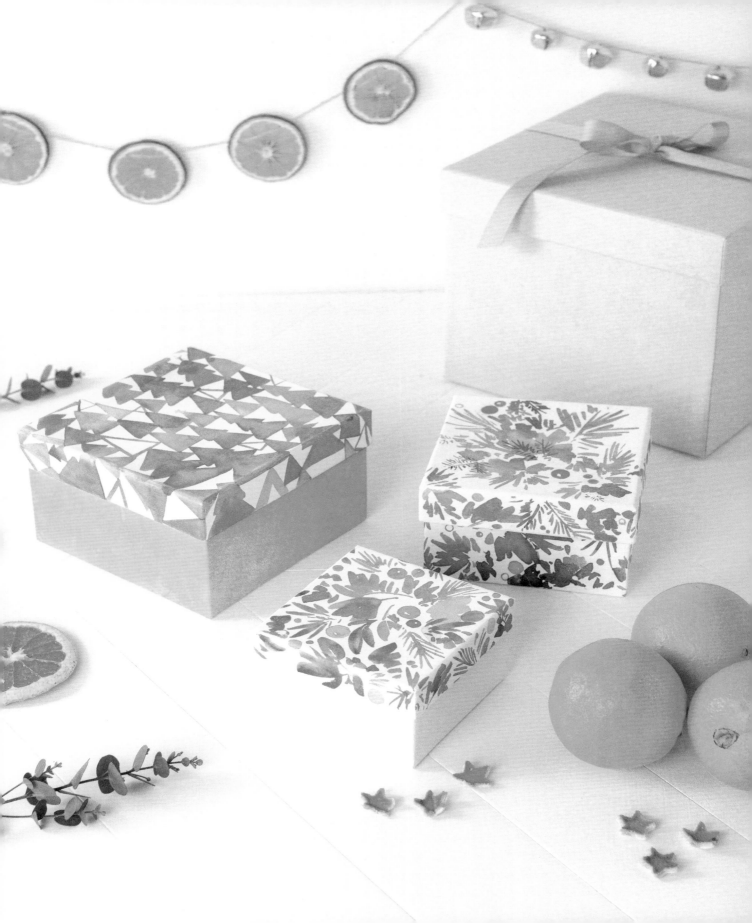

PREPARING THE BOXES

1 If the box you intend to use has an image or color that needs to be covered, it's advisable to paint it first with white acrylic. Once dry, paint the surfaces to be painted with watercolors with a thick coat of watercolor ground and leave to cure for 24 hours.

PAINTING THE CHRISTMAS TREES DESIGN

2 Working on the box lid, paint a blue triangle and, while it is still wet and just below the first triangle, paint another this time using green – you have completed a simple Christmas tree. (If you want a taller tree, simply add a third triangle beneath the second one.)

3 Paint another tree in the same way close enough to the first so the colors can blend.

4 Add a star to the top of some of your trees to give a little extra interest.

5 Continue to add trees in this way until the whole of the box lid is covered, working over the sides of the box lid too. Note how I have changed the sizes of my trees for variety, sometimes painting in just a single large triangle to make a tree, or painting only the outline of a triangle (this gives the eye a rest while still filling the space between the trees).

6 For the box base, you can choose to continue the same design as the box lid or just paint it with a plain color. I chose to paint mine gold using golden watercolor ground. This way the busy pattern of the lid gets highlighted and there is space for the eye to rest.

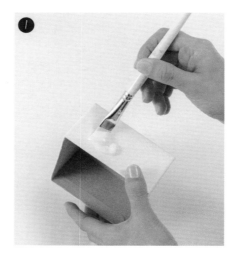

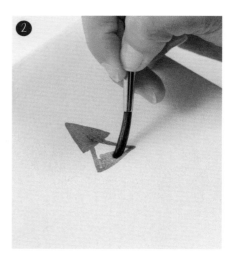

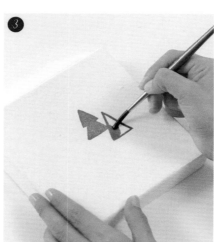

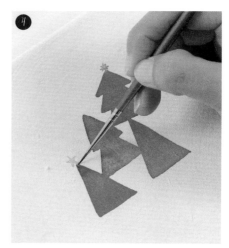

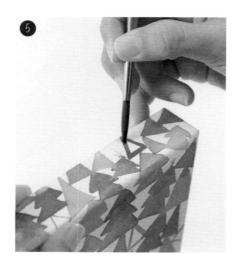

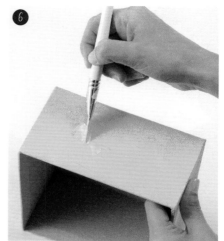

PAINTING THE EVERGREEN DESIGN

7 With a mix of green and blue, paint fine lines to join in a main branch to resemble pine needles, distributing them around the box lid.

8 Use thicker brushstrokes to imitate the shapes of ivy or holly leaves to fill the space in between the pine needle sprigs. Fill any spaces in between the leaves by painting simple red circles for the berries.

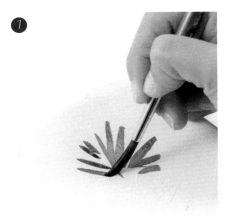

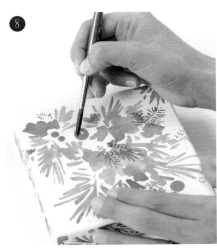

The Evergreen design.

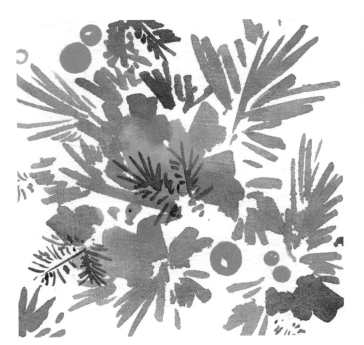

The Christmas Trees design.

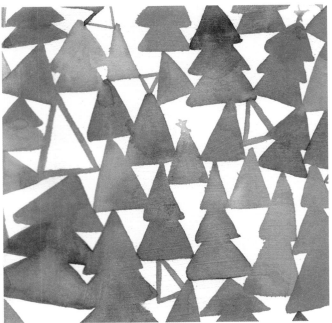

Patterned Garlands

No matter the season, garlands are always a sign of a special celebration, so I've made this one to hang at the window using some shaped wooden baubles that are perfect for the job. I have used watercolor ground in two colors as the background for the simple patterned designs, which is a wonderful way to make the most of the translucent quality of the watercolor medium. Each set complements the other beautifully, but the differences between the two are quite amazing when you consider that exactly the same colors of paint have been used to make identical patterns.

YOU WILL NEED

- Watercolor ground in white and gold
- White acrylic
- Wooden shapes readily available from art and DIY shops
- Brushes: see Materials and Equipment
- Ribbon

MY PALETTE

Mixed from: Intense Green, Olive Green, Phthalo Green, Cyan, Phthalo Turquoise, Prussian Blue, Indigo.

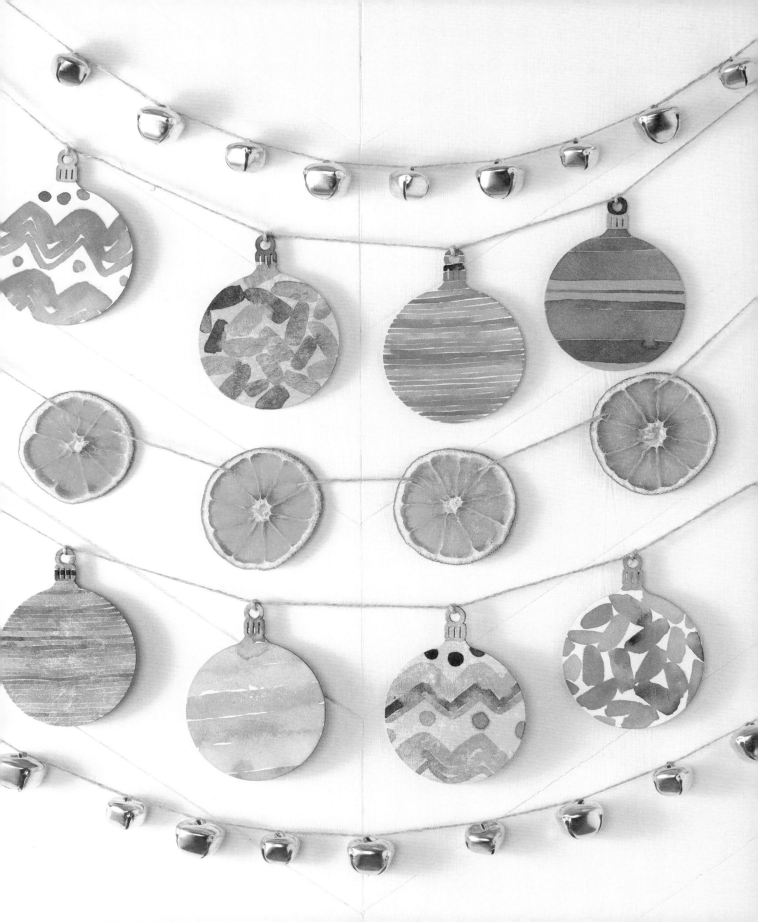

PREPARING THE SHAPES

1 Paint one side of all your shapes with a coat of white acrylic and allow to dry; then paint the other side. Once dry, paint half of the shapes with white watercolor ground and the other half with golden watercolor ground, remembering to do this on both sides. For best results, leave for 24 hours to cure.

DECORATING THE SHAPES

2 Thin horizontal lines Choosing a brush that will allow you to make the thinnest possible line, paint your first line, then slightly change the color on your brush and paint a second line as close to the first as possible (it's okay to let the lines touch each other). I've started with green, adding a little bit of blue each time, then when it is completely blue, I've gone back to green, continuing in this way to fill the shape with thin horizontal lines.

3 Wide horizontal lines To paint thick horizontal lines, apply more pressure on your brush (or you can choose to use a thicker brush). Allow the lines to touch each other, but to create contrast make sure that you change the color of each line.

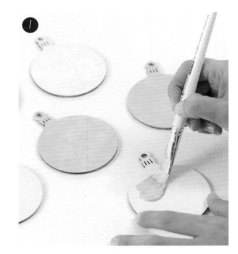

Since watercolor is sensitive to light, it is recommended that a UV protection spray be applied to the shapes, especially if you intend to hang the garland at a window. Do it at some distance, so they receive only a mist of the spray.

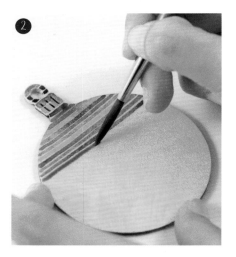

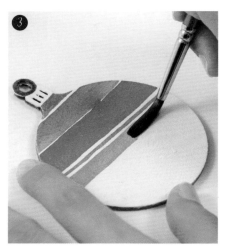

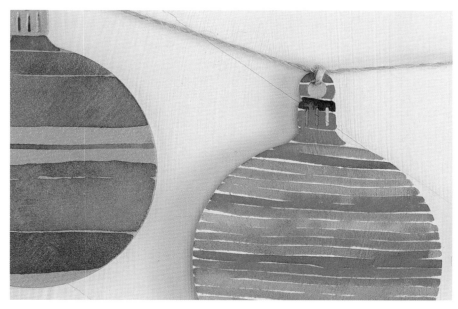

4 Confetti Use a medium-size brush to paint thick confetti-like lines. Start with one short line in cyan.

5 Paint more lines, changing the colors to green and turquoise. Let the colors blend into one another by allowing the lines to touch.

6 Zigzag Paint a thick zigzag line using green and, before it dries, paint a second zigzag line using blue, then a third zigzag line in a different color, reducing the thickness of the lines each time. Repeat to paint a second set of zigzag lines beneath the first set. Fill the space above and below the first set of zigzag lines by adding a few dots.

7 Once the shapes are dry turn them over and paint the patterns on the reverse.

MAKING THE GARLAND

8 Thread a ribbon (or yarn) through the holes at the top of the shapes to make your garland, alternating shapes with gold and white backgrounds.

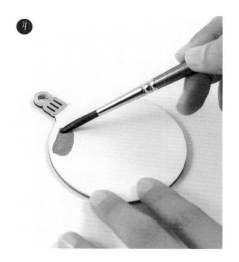

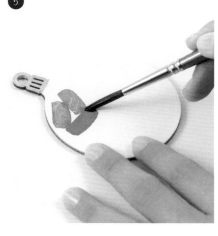

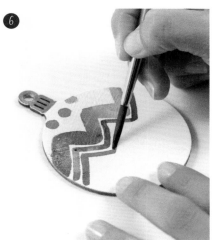

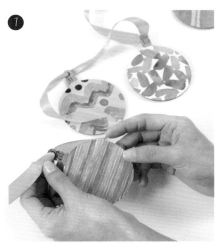

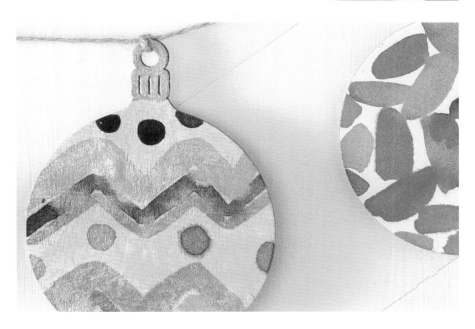

Paint the same designs on both sets of shapes. Note how the same colors look different on those shapes prepared with the white watercolor ground as opposed to the gold, but they complement each other beautifully.

Galaxy Ornaments

I grew up close to a little town in Mexico that creates colorful glass ornaments all year round, which my mother loves to collect. Each year she picks a theme and color for our family tree and the creativity never fails to amaze. Her collection has all kinds of shapes on ribbons of every color you can imagine, but perhaps most special of all are the ornaments my sisters and I painted as children! I have chosen a galaxy theme for my step-by-step instruction for how to paint on glass, using star-shaped baubles that lend themselves perfectly to this, but feel free to explore any design idea you choose.

YOU WILL NEED

- Star-shaped glass ornaments
- White acrylic
- Watercolor ground
- White gel pen
- Alternative materials of your choosing
- Brushes: see Materials and Equipment
- Toothbrush or brush with stiff bristles
- Spray bottle (optional)

MY PALETTE

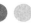

Mixed from: Cyan, Prussian Blue, Indigo, Payne's Grey, Ultramarine Blue, Cinnabar Red. To give each bauble its own personality, change the dominant blue for each. Indigo and Payne's Grey will result in an intense shade, and by adding a little Cinnabar Red to the mix we get a lovely purple.

PREPARING THE GLASS STARS

1 Remove the metal cap from your glass stars first, then paint them all over with a coat of white acrylic. Once dry, paint with white watercolor ground and allow to cure for 24 hours.

DECORATING THE ORNAMENTS

2 Working on one side at a time, paint each glass star with a wash, using different shades of blue for each. Referring to Experimental Watercolor, apply the texturing effect of your choice. I've used a combination of salt and alcohol but you might like to try soapy water too. You will notice how the effects are almost immediate. Leave to dry, then repeat to decorate the other side of the star.

3 You may be happy with the effect you have achieved, but if you would prefer more texture or a deeper color, add a second layer. Do keep in mind that by doing this any effect achieved in the first layer will disappear.

4 Alcohol creates a really interesting 'crater' effect if sprinkled (see detail photo), so try using a spray bottle for this.

It is normal for the paint to drip even though you will be using less water than when working on paper: a piece of kitchen towel placed beneath each bauble will help to keep your work surface clean.

Alternative materials react faster and differently on the watercolor ground. Experiment with one glass star first. If you don't like the result, simply wash it with water, allow to dry and it will be ready to use again.

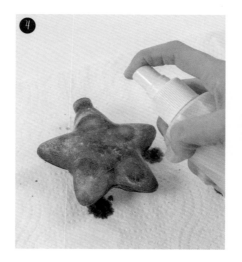

GALAXY ORNAMENTS

5 Use a toothbrush or a brush with stiff bristles to splatter white acrylic paint over the stars, working on one side at a time. Try adding a drop of water to your acrylic mix to make it easier to apply. Leave to dry.

6 Use the white gel pen to draw on various celestial decorations including shooting stars, moons and constellations. Once the decorated stars are completely dry, you can carefully put the metal caps back on and hang them on your tree.

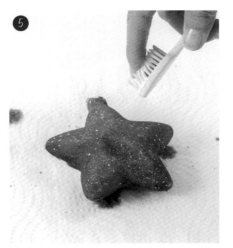

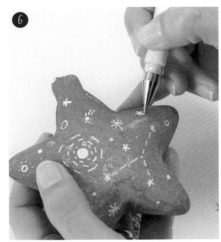

Glass ornaments can be found in many different sizes and shapes. Inspired by my mother's vision, that we can pick any theme and color we like and apply it to our decorations, I chose a traditional circular shape for these botanical baubles.

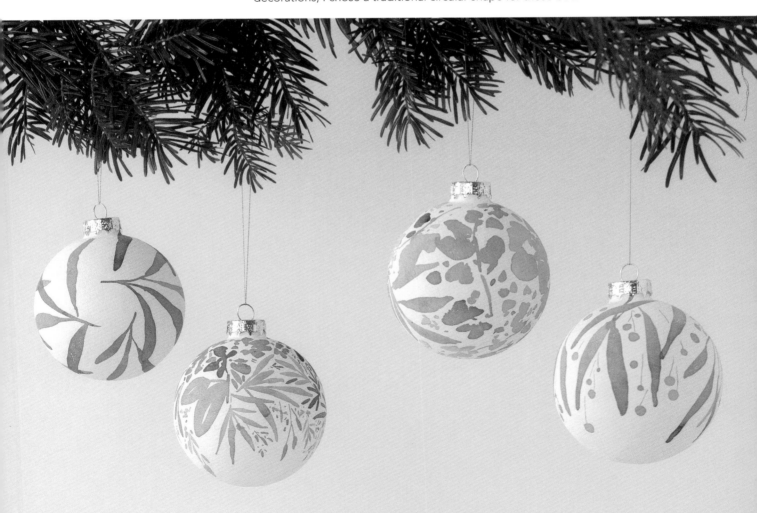

Kirigami Decorations

My sister made me an origami giraffe a few years ago, mesmerizing me with the magic of her paper folding, and ever since I have loved this ancient art. If you visit my studio you will find folded paper shapes hanging everywhere. It is not surprising then that I decided to use some of my discarded artworks to create some folded decorations for this book. But, as watercolor paper is too thick to fold, I have explored kirigami, a variation of origami where paper is cut, folded and glued to make all kinds of shapes.

YOU WILL NEED

- Watercolor artworks
- Watercolor resources for reworking your artwork pieces, including paints, brushes and additional materials for creating textures
- Box cutter and ruler
- Circle compass cutter or scissors
- Pencil
- Glue or double-sided tape

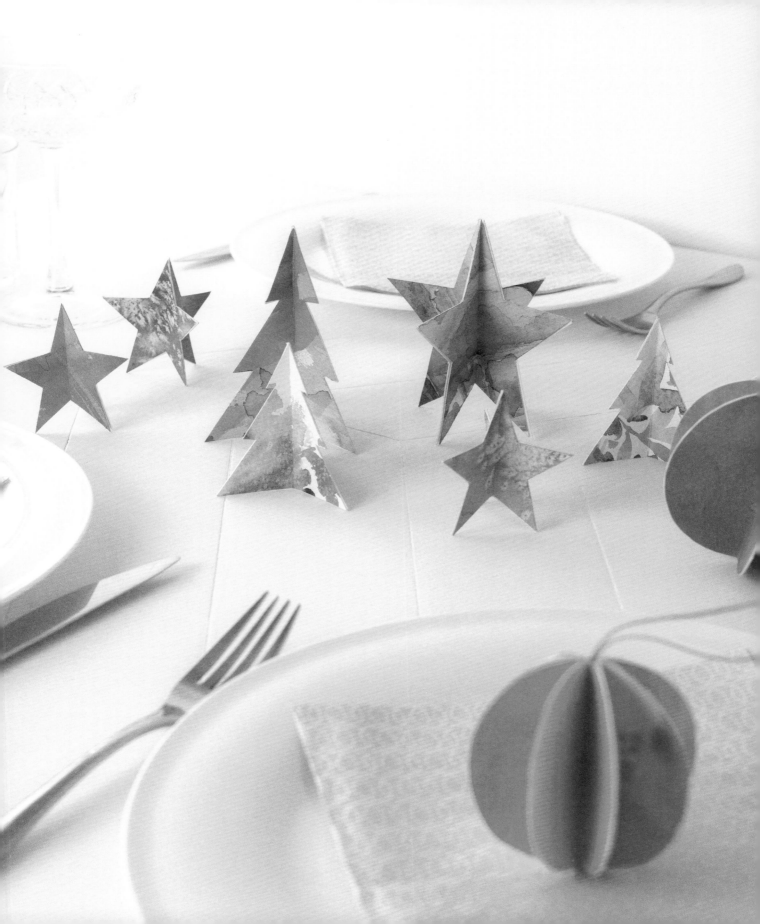

PREPARING THE WATERCOLOR ARTWORK SHEETS

1 I have made my kirigami decorations by reusing older pieces of my work, but you can paint something new if you prefer. If you are reusing work, organize your pieces by color. Ideally, we would use green to make the Christmas trees, blue or purple for the stars, and a variety of other colors for the spheres. If your pieces have too much white, you could apply a wash over them. Watercolor is translucid, so by doing so we will enhance the main color while preserving the original brushstrokes.

If your sketches lack interest, they can be reworked to add more color or texture – use bold brushstrokes, splatter with inks or acrylics, or apply alternative materials such as salt or alcohol over the wash.

To convert your decorations into hanging ornaments place a cord between the last two pieces to be glued together.

MAKING A SPHERE

2 Use a circle compass cutter to cut out at least eight circles from your paper with a diameter of 3½in (9cm); alternatively, use a glass to trace a circle shape and cut out with scissors.

3 Fold each circle in half with the art facing inwards.

4 Glue the back (white) side of one half of one circle to one half of the next circle, continuing until each circle is attached to the next, accordion-style, and the sphere is complete.

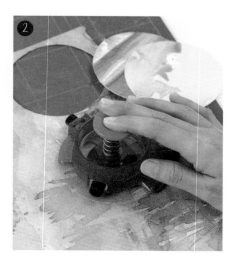

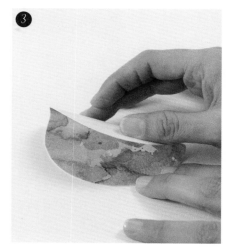

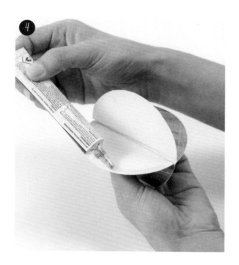

MAKING THE OTHER SHAPES

5 The stars or Christmas trees are made in a similar way to the spheres but only three of each shape are required (although if the paper is not too thick more pieces can be used). Mark out your star or tree shape onto your paper. Note that the shape must be symmetrical when folded in half.

6 Cut out your star or tree shapes and fold in half as you did for the spheres.

7 Glue the shapes together following step 4 of Making a Sphere.

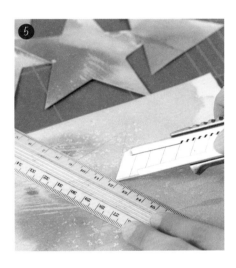

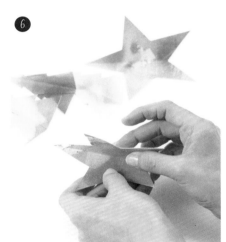

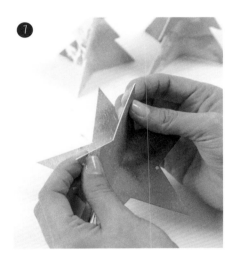

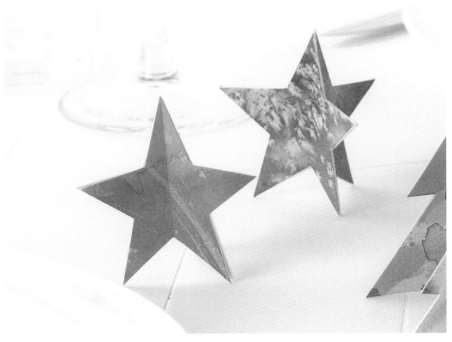

I cut my shapes from the same piece of artwork for each decoration, but mixing styles within each would be interesting.

Motif Gallery

MOTIF GALLERY

ABOUT THE AUTHOR

Ingrid Sanchez, also known as CreativeIngrid, is a Mexican-British watercolor artist based in London, UK. She has a bachelor's degree in Information Design and an MA in Book Publishing. After years of working in the publishing industry, she decided her passion for art was too strong to ignore, and took the opportunity of a year abroad in NYC to paint and learn from as many artists as possible.

Ingrid teaches workshops all over the world including London, Mexico, Barcelona and NYC. Her original watercolors, art prints and other products showcasing her art can be found on her website ingridsanchez.com, and a wider variety of products can be found under art license agreements with several different brands around the world.

To learn more about Ingrid's unique painting process, please visit Instagram.com/CreativeIngrid.

ACKNOWLEDGEMENTS

Watercolor has been for me the best therapy I could have had and the best friend I could ever have imagined. I started painting at a very young age, but only came to this medium in adulthood after years of frustration. Living a 'traditional' life never felt right for me, and on my journey of discovering my artistic self, the watercolor medium taught me the importance of letting go and of embracing the inevitable mistakes that are part of the process.

I want to thank everyone who has encouraged me to follow my creative path because by doing so I finally found myself. To Henry, who has always encouraged me to follow my heart, your support means the world.

To my dad who gave me my first art set, and my mom who loves Christmas and still keeps my earliest creations on her walls. To my sister Diana for her eternal support. Thank you, Wendy, for being my first and most active collector.

To every student, to every buyer, and to every person following my art, thank you because you are the reason I can continue to do what I most love in the world. To all the artists and creatives out there that bring inspiration into the world, thank you for showing me different ways of seeing the world.

Finally, to Ame and all the team at David and Charles for presenting me with this project and for helping me to bring it to life.

INDEX

A DAVID AND CHARLES BOOK
© David and Charles, Ltd 2021

David and Charles is an imprint of David and Charles, Ltd
Suite A, Tourism House, Pynes Hill, Exeter, EX2 5WS

Text and Designs © Ingrid Sanchez 2021
Layout and Photography © David and Charles, Ltd 2021

First published in the UK and USA in 2021

ISBN-13: 9781446308448 paperback
ISBN-13: 9781446380130 EPUB

This book has been printed on paper from approved suppliers and made from pulp from sustainable sources.

Printed in the UK by Buxton Press for:
David and Charles, Ltd
Suite A, Tourism House, Pynes Hill, Exeter, EX2 5WS

10 9 8 7 6 5 4 3 2 1

Publishing Director: Ame Verso
Editor: Jessica Cropper
Project Editor: Cheryl Brown
Head of Design: Sam Staddon
Pre-press Designer: Ali Stark
Illustrations: Ingrid Sanchez
Photography: Jason Jenkins
Photographs of the author: Inna Kostukovsky
Production Manager: Beverley Richardson

David and Charles publishes high-quality books on a wide range of subjects. For more information visit www.davidandcharles.com.

Layout of the digital edition of this book may vary depending on reader hardware and display settings.